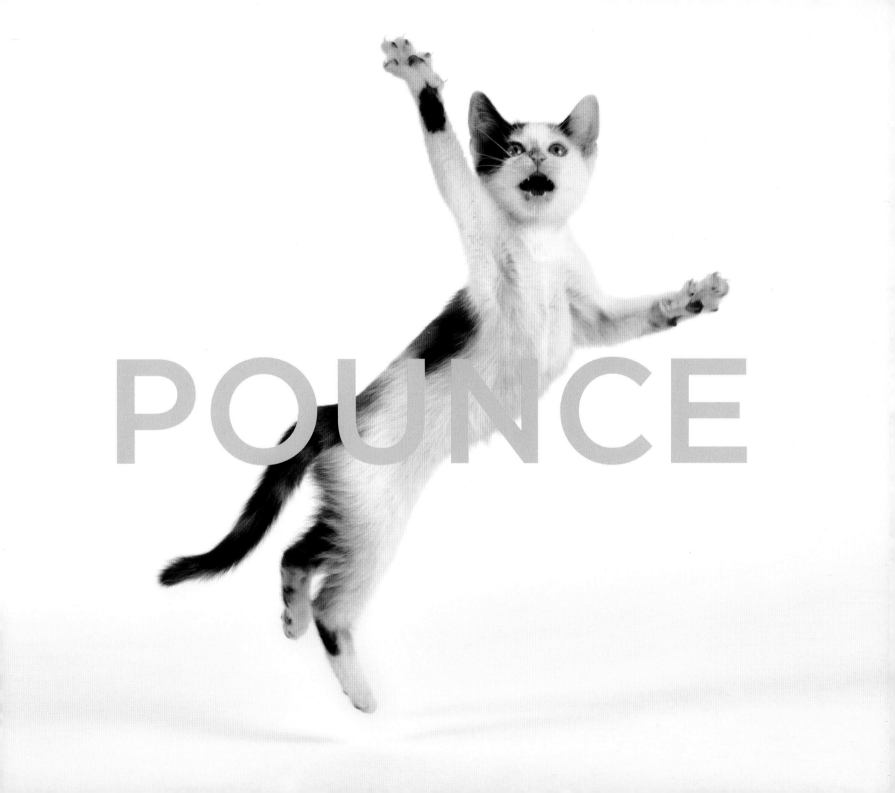

Also by Seth Casteel

Underwater Babies

Underwater Puppies

Underwater Dogs

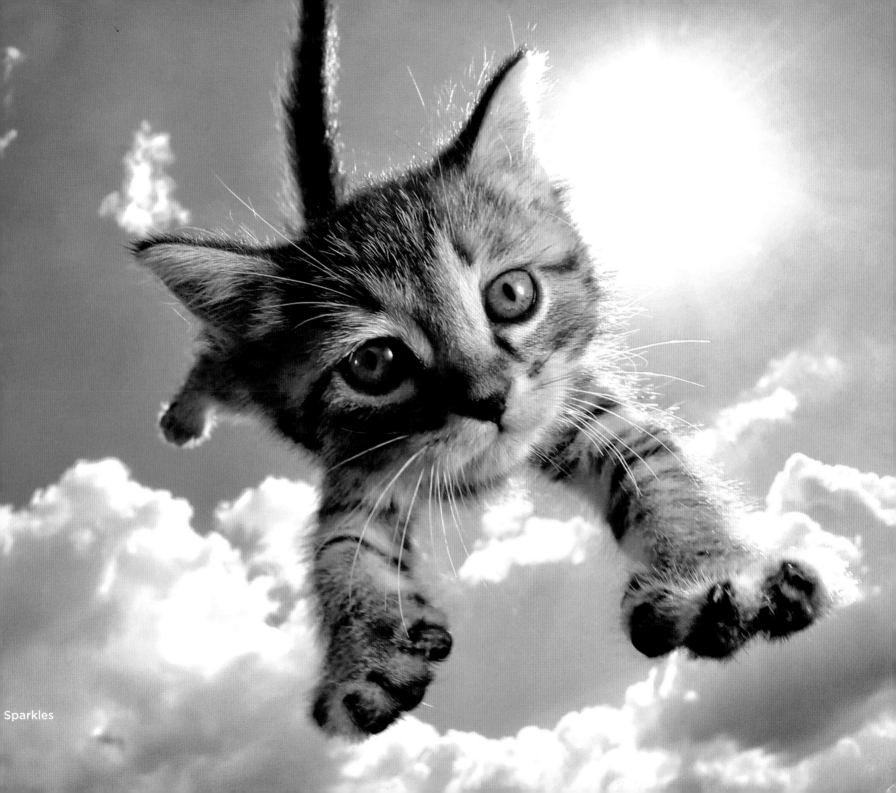

Sparkles

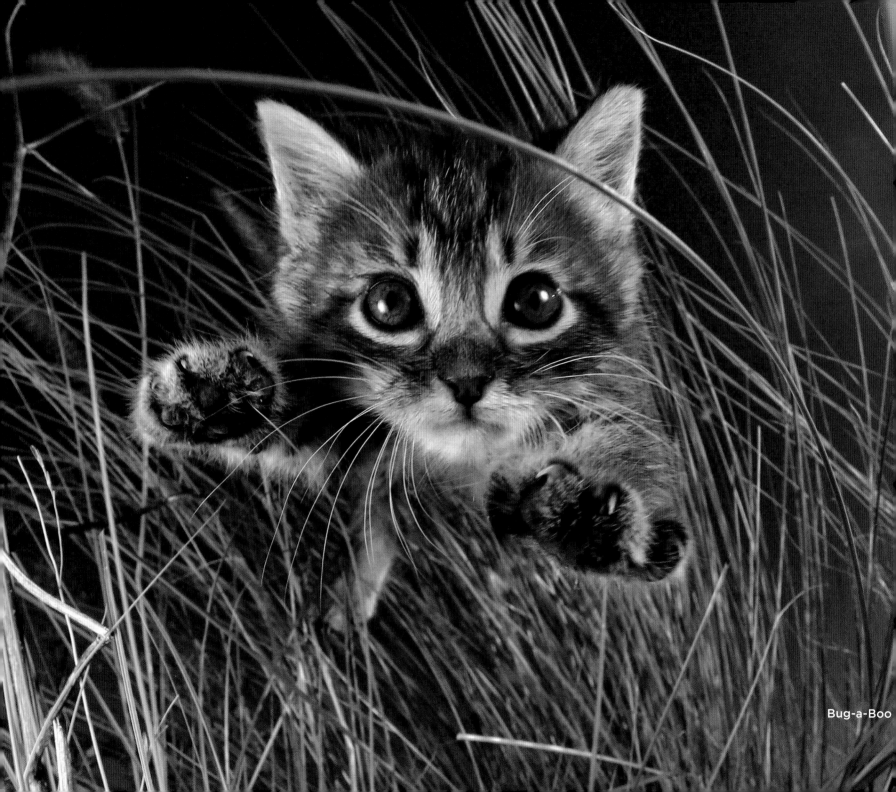

Bug-a-Boo

POUNCE

Seth Casteel

LITTLE, BROWN AND COMPANY
New York Boston London

Little, Brown and Company
Hachette Book Group
1290 Avenue of the Americas, New York, NY 10104
littlebrown.com

First Edition: October 2016

Little, Brown and Company is a division of Hachette Book Group, Inc. The Little, Brown name and logo are trademarks of Hachette Book Group, Inc.

The publisher is not responsible for websites (or their content) that are not owned by the publisher.

The Hachette Speakers Bureau provides a wide range of authors for speaking events. To find out more, go to hachettespeakersbureau.com or call (866) 376-6591.

ISBN 978-0-316-34922-2
LCCN 2016932789

10 9 8 7 6 5 4 3 2 1

APS

Design by Gary Tooth / Empire Design Studio

Printed in China

This book is dedicated to the humans who work tirelessly to help our cat friends.
Thank you for all that you do!

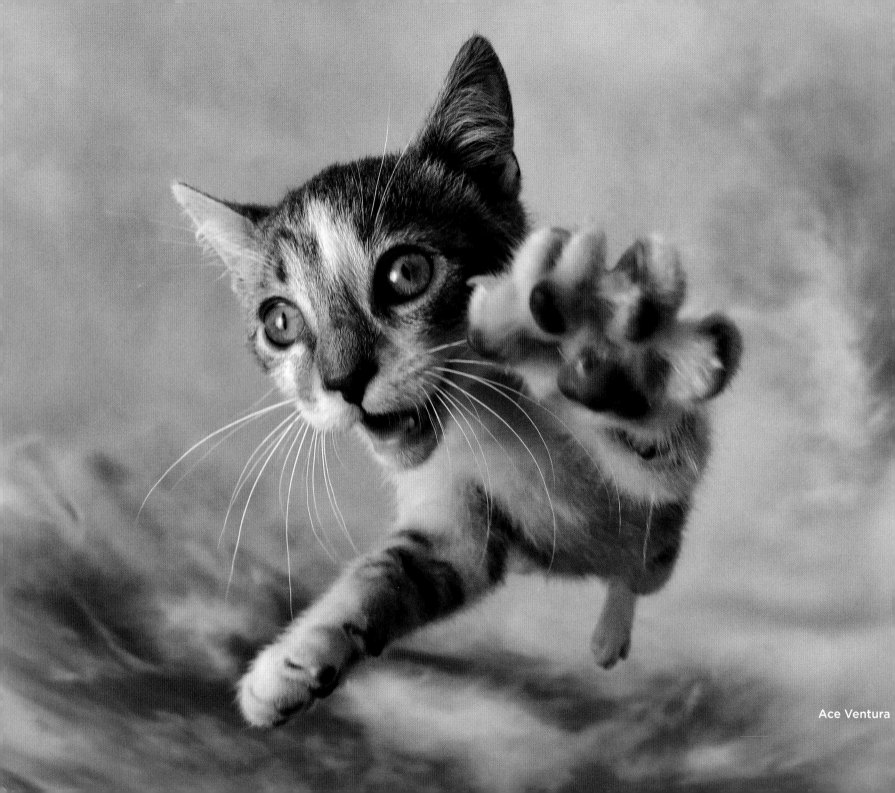

Ace Ventura

CONTENTS

INTRODUCTION

Some of you folks may know me as the *Underwater Dogs* guy. I obviously love dogs and have spent many years—full of curiosity and delight—chasing them around with a camera in hopes of better understanding why they are just so awesome. But you should know that before I was photographing dogs underwater I was photographing *cats on land*. That's how my career as a photographer and author actually began.

While working at a Los Angeles movie studio in 2007, I became friends with the "cat people" who cared for the community of cats living on the studio backlot. They provided food and water for the kitties but also ensured they were spayed and neutered. Life was pretty good for these kitties, and the word got out, which inspired more to move in. Not surprisingly, baby cats began popping up. My "cat people" friends became a little over-whelmed, and I, having just acquired my first digital SLR camera, offered my photographic assistance, although at the time I wasn't sure if I could truly help: I barely knew how to work the camera and had no idea how to work with cats.

One day, while a senior executive was out to lunch, we snuck the kittens into his office and let them pounce around on the furniture as I snapped candid pictures. And the pictures looked great! But let's be honest: I think it's impossible to take a bad picture of a kitten. Kittens are the cutest creatures on the planet!

Using the studio's email network, we blasted out the kitten pics and info to our colleagues. Apparently the email network was not intended for this kind of message, but we thought surely we couldn't get fired for helping kittens. And we were right. Not only did we keep our jobs, but because of the pictures, all the kittens were adopted within hours! It was at this moment that I realized the power of a photograph, and I became obsessed. I photo-graphed another litter of homeless kittens. And then I started volunteering at the local animal shelter, photographing both cats and dogs, and then at another shelter, and then at shelters in different states, and then at shelters in different countries.

I want to thank that litter of kittens for inspiring what has become my purpose in life—to try to make the world a better place through photography.

CREATING THE BOOK

For a while now I've been excited to make a photography book about cats. But to answer the question I am asked most often: after an extensive worldwide search for "cats who willingly dive into swimming pools," I found approximately zero participants. So unless something radically changes with the behavior of cats around water, *Underwater Cats* is permanently on hold.

For me, the *only* book to create about cats would feature them

doing what they do best—*pouncing!* The undisputed number one instinct of cats, pouncing makes them among the most incredible creatures on earth. From their initial reaction upon seeing the prey to their stealthy stalk to their sudden burst of dynamic energy—watching a cat pounce inspires in us humans a range of emotions: respect, fear, joy, disbelief.

I collaborated with numerous animal shelters and rescue groups in the United States and Canada to create this series of images. Every single cat in this book was available for adoption or already rescued at the time I took the pictures. This project was by far the most challenging I ever experienced. Dogs are easy to photograph. Cats—not so much. A typical day of shooting for *Pounce* looked like this:

9:00 a.m.: Arrive at a home where an "amazing pouncing cat" lives.

11:00 a.m.: I have yet to see the cat.

11:45 a.m.: On a nearby wall, a shadow appears that resembles a cat, but it turns out it's just the dog again.

1:00 p.m.: At this point, I've heard the line "Cuuuuuudles, where aaare you?" at least a thousand times.

2:00 p.m.: Cuddles is carried out to the room where I am sitting. Finally I can begin to take pictures.

2:00 p.m. and three seconds: Cuddles is nowhere to be seen.

Even the friendliest cats can be wary of new people and new things, such as my camera and flashes. With dogs, I can bribe a friendship with a toy or a treat. With cats, it doesn't always work that way.

I explored dozens of different ideas to solve this riddle and ultimately wound up working with mostly younger cats due to their slightly more easygoing attitude, boundless energy, and athleticism. To get the cats to pounce, I experimented with more than two hundred cat toys and countless movement tactics. Four out of those two hundred toys proved to be consistently good, generating multiple pounces both directly at the camera and nearby. For the majority of the photos in this book, I wasn't able to look through the viewfinder, so I had no idea if the cat was even in the picture until after the pounce occurred. The reason for this was I attached cat toys to the camera itself and used it as a lure. Voilà! Of course, a number of cats pounced on the actual camera, and more cats than I care to admit pounced into my hair. They just loved something about my hair. Eventually I had to wear a beanie to avoid any more cats leaping onto my head.

HELPING CATS

There are an estimated 86 million pet cats living in the United States and an estimated 30 to 40 million community cats, or strays. A female could have more than 100 kittens in her lifetime. A single pair of cats and their offspring can produce as many as 420,000 kittens in just seven years.

Every year 1.4 million cats are euthanized due to pet overpopulation. According to the Humane Society of the United States, the ASPCA, and Best Friends Animal Society, here are a few ways you can help:

1. Spay and neuter your cats. There are many low-cost and even free options to sterilize your cat. Contact your local animal shelter or welfare organization for details.

2. Become a foster-cat parent. Consider temporarily bringing a cat, kitten, or litter of kittens into your home to provide care until a permanent home is found.

3. Adopt a cat from your local animal shelter or rescue group.

Thank you for looking at my photographs and going on this journey with me—and with these incredible cats!

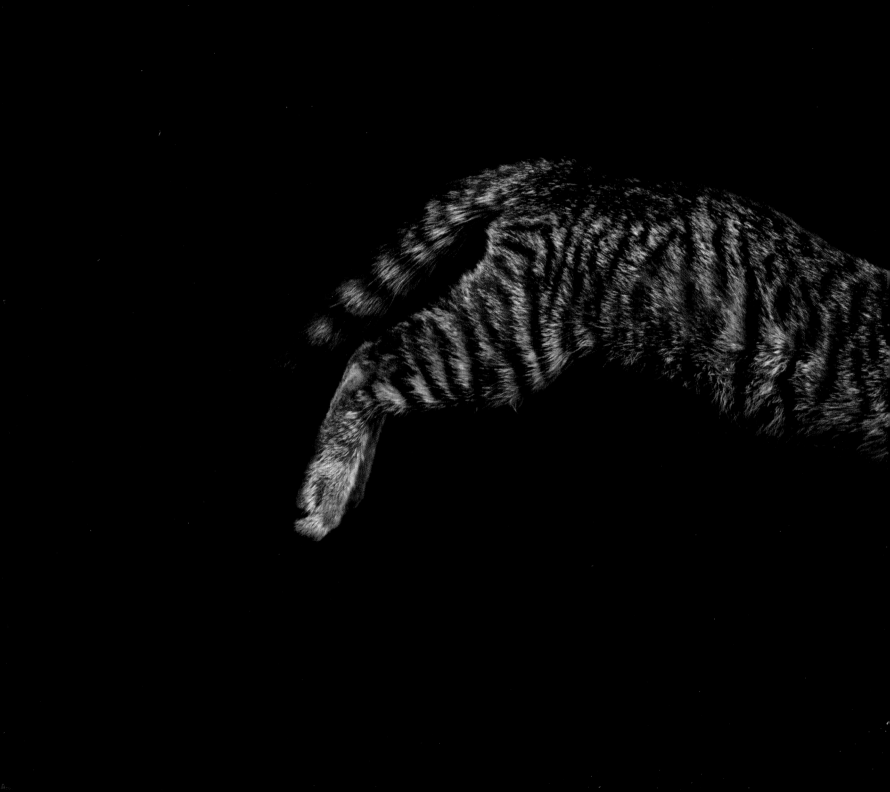

POUNCE

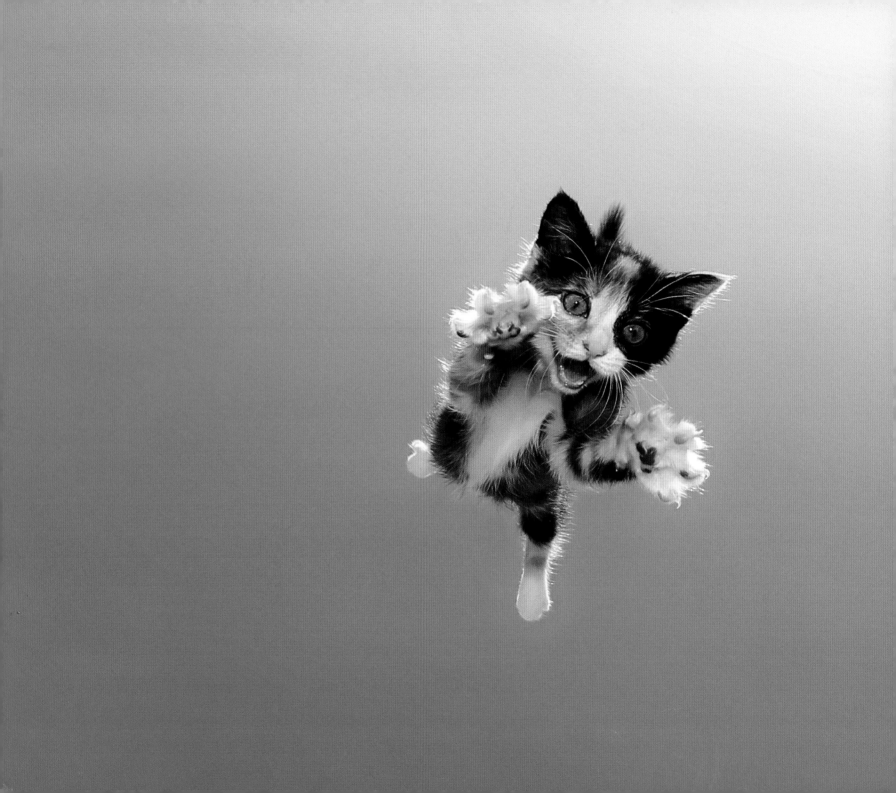

Zeppelin

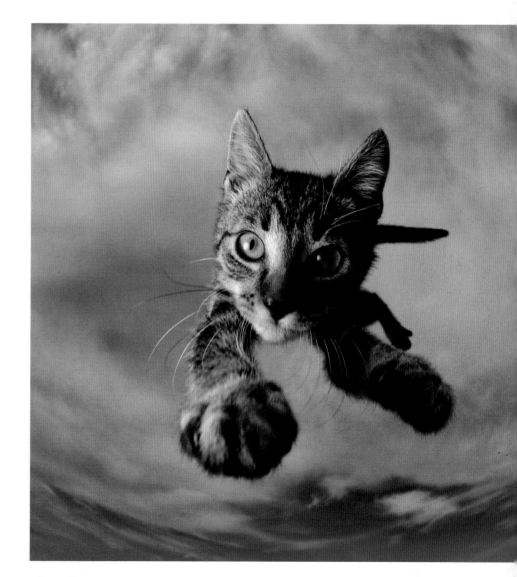

Skywalker

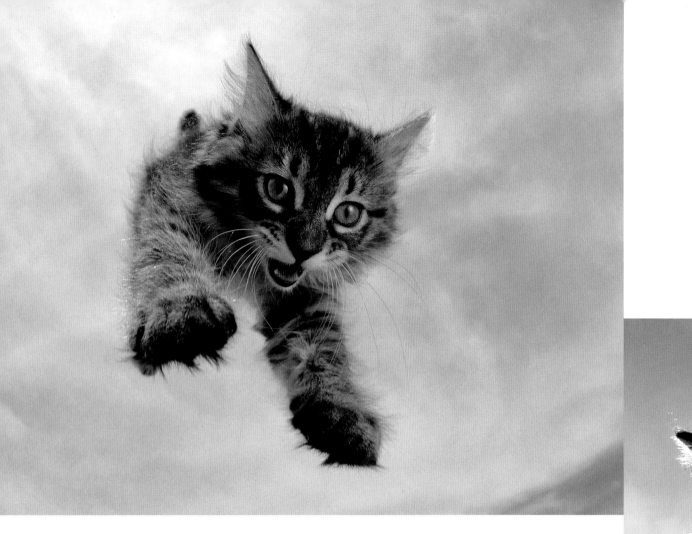

Doc Brown

Willy Wonka

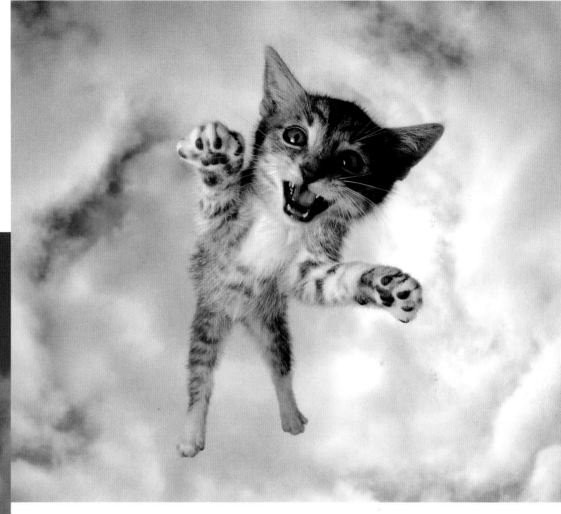

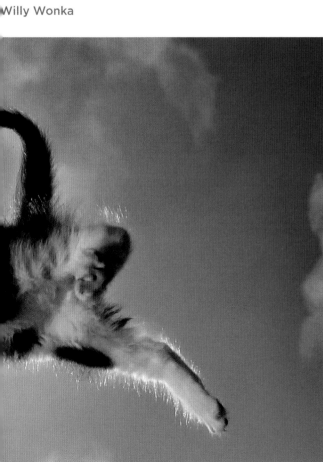

Zagnut

FruityPebble

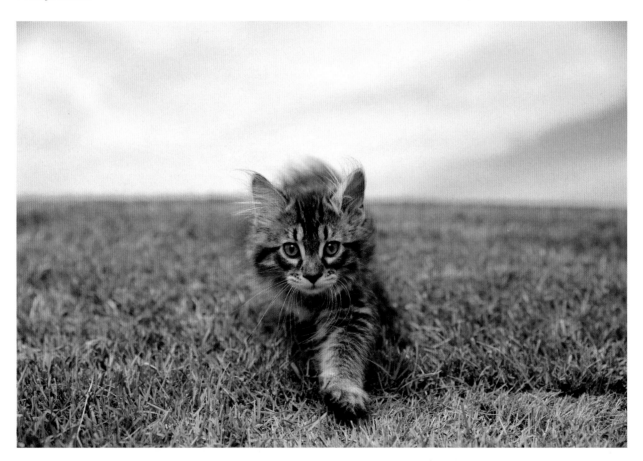

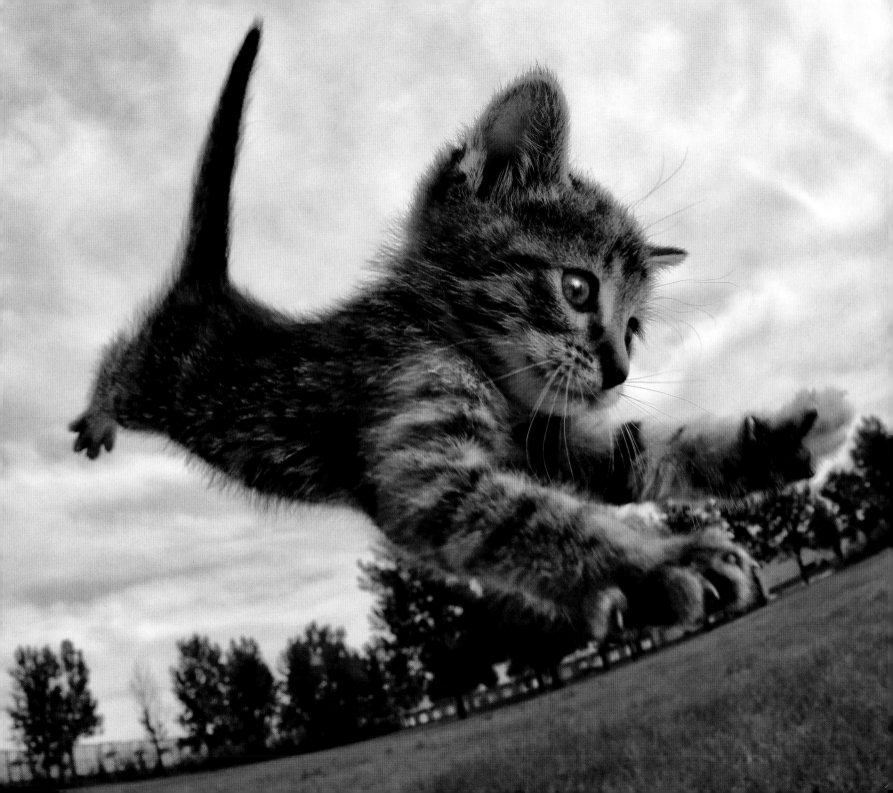

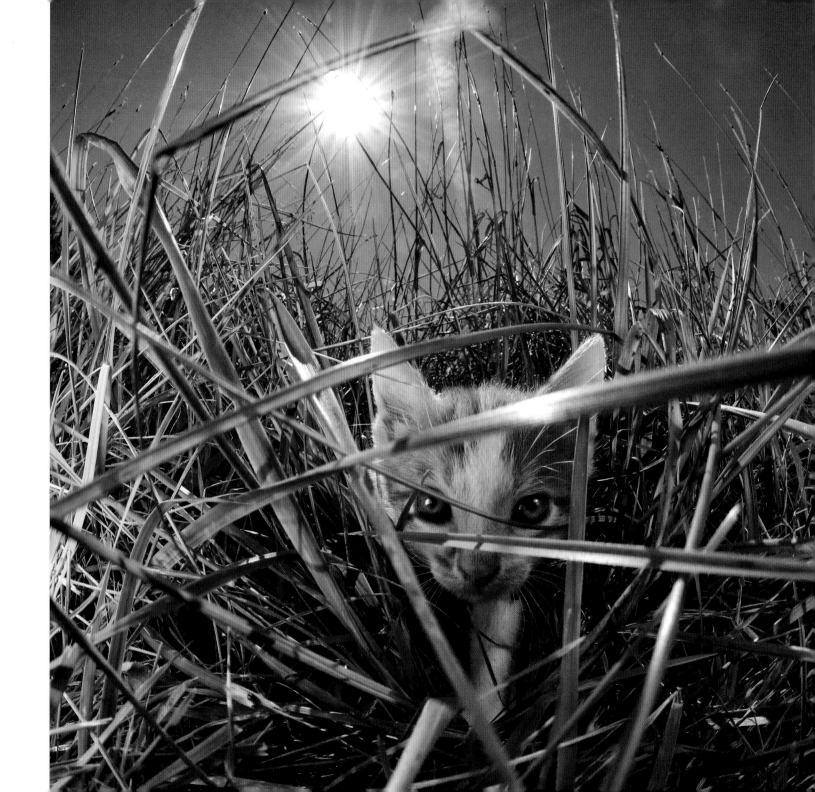

Neo

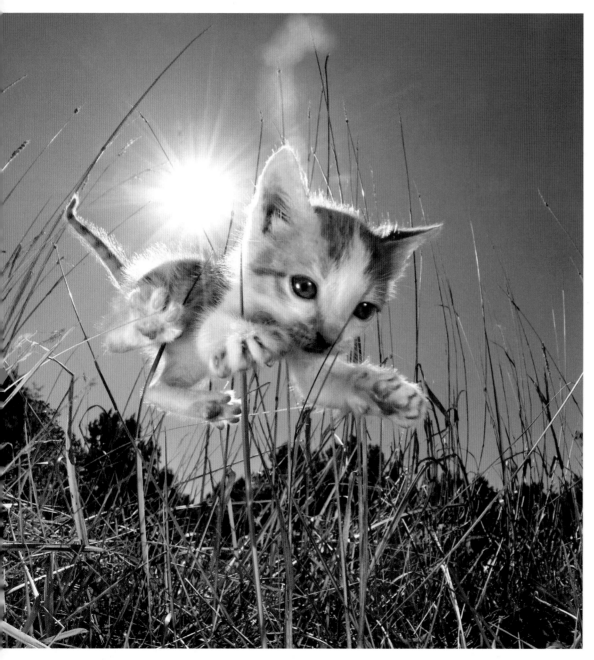

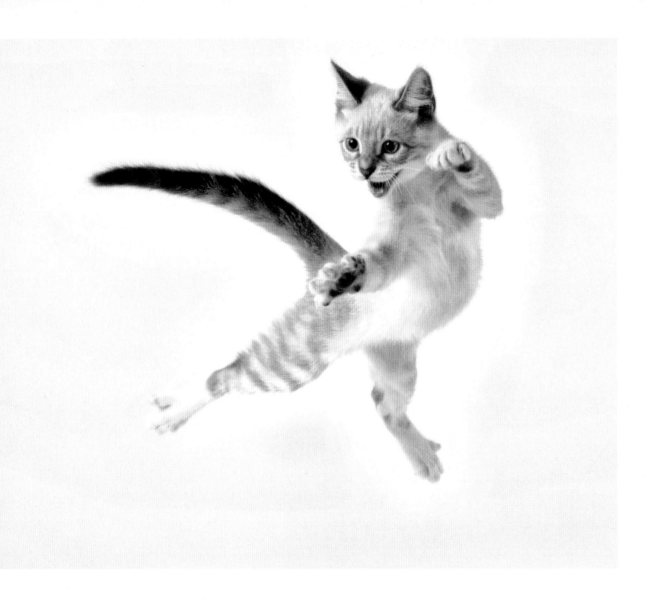

Donut

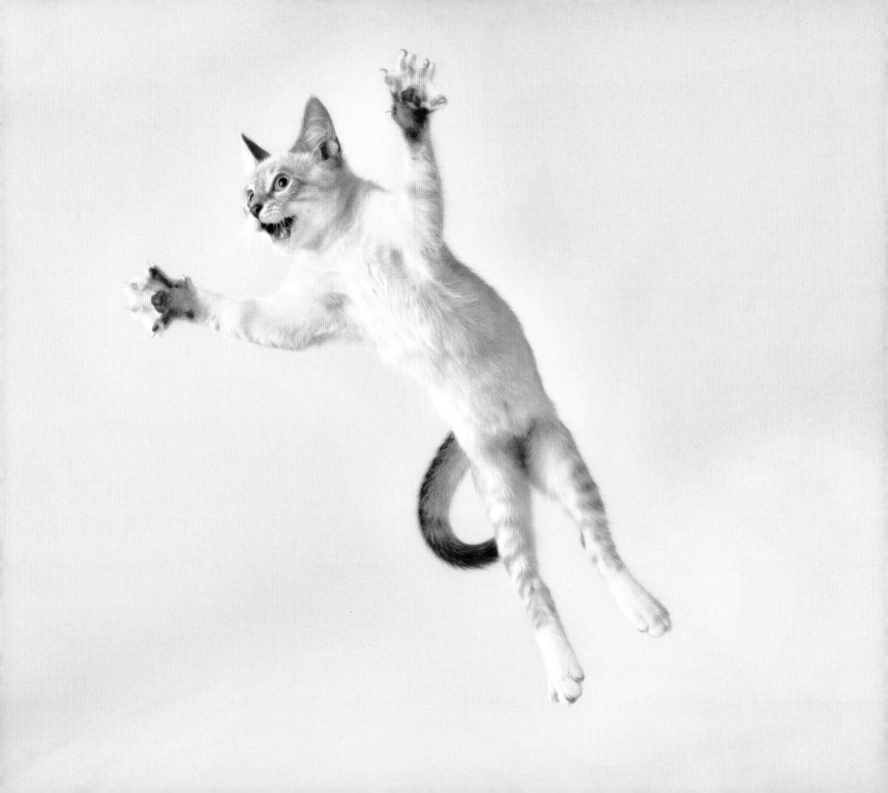

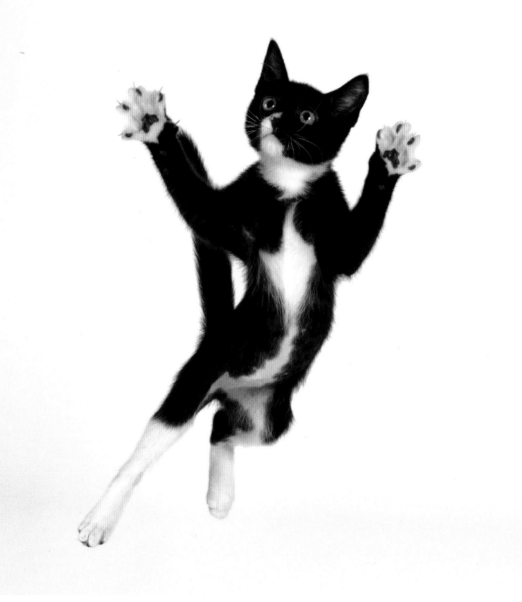

Popeye

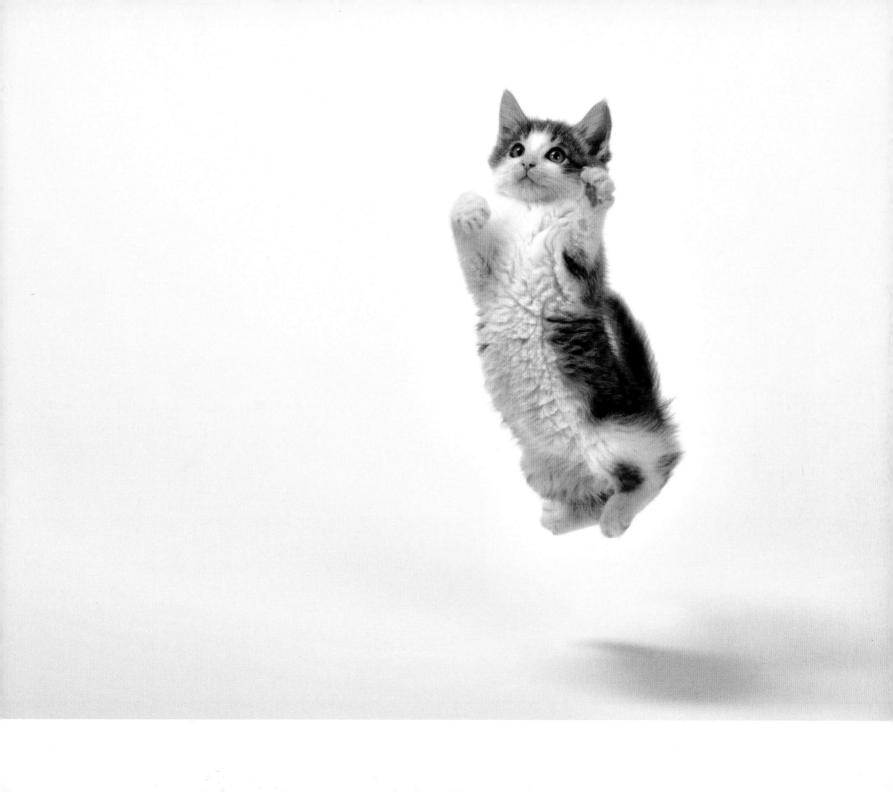

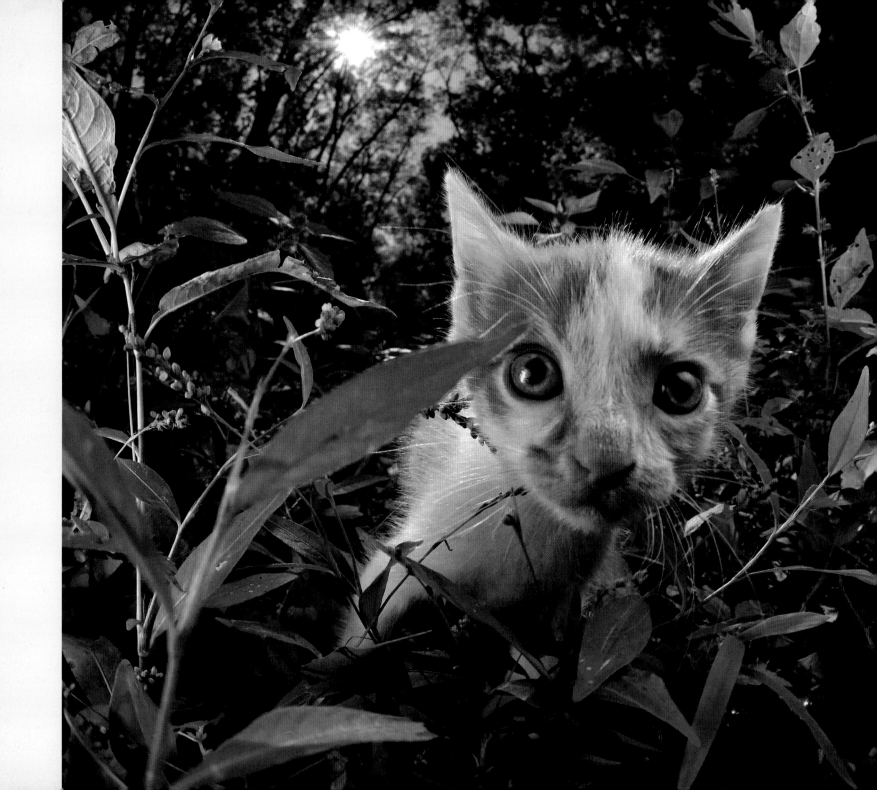

Fuzzbucket

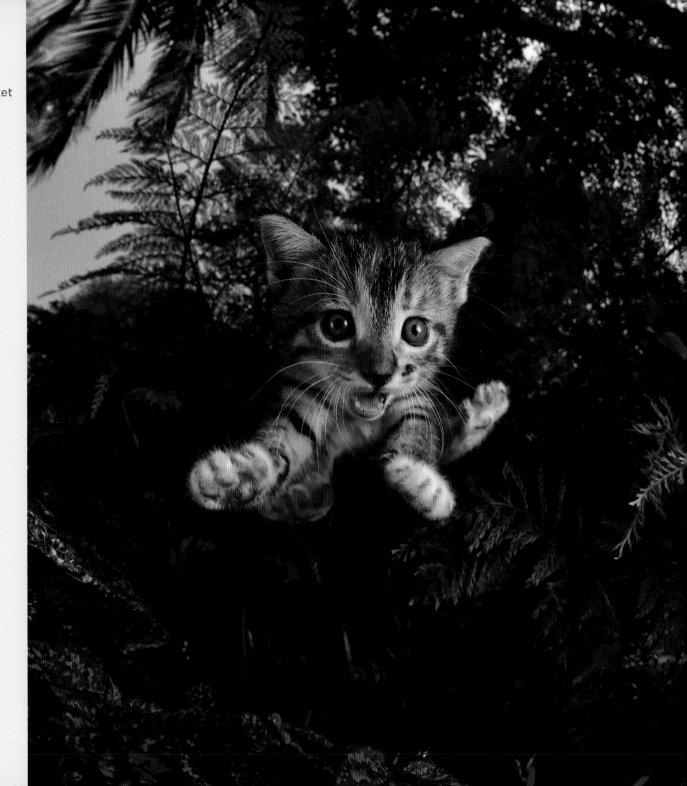

Pokémon

Pandabear

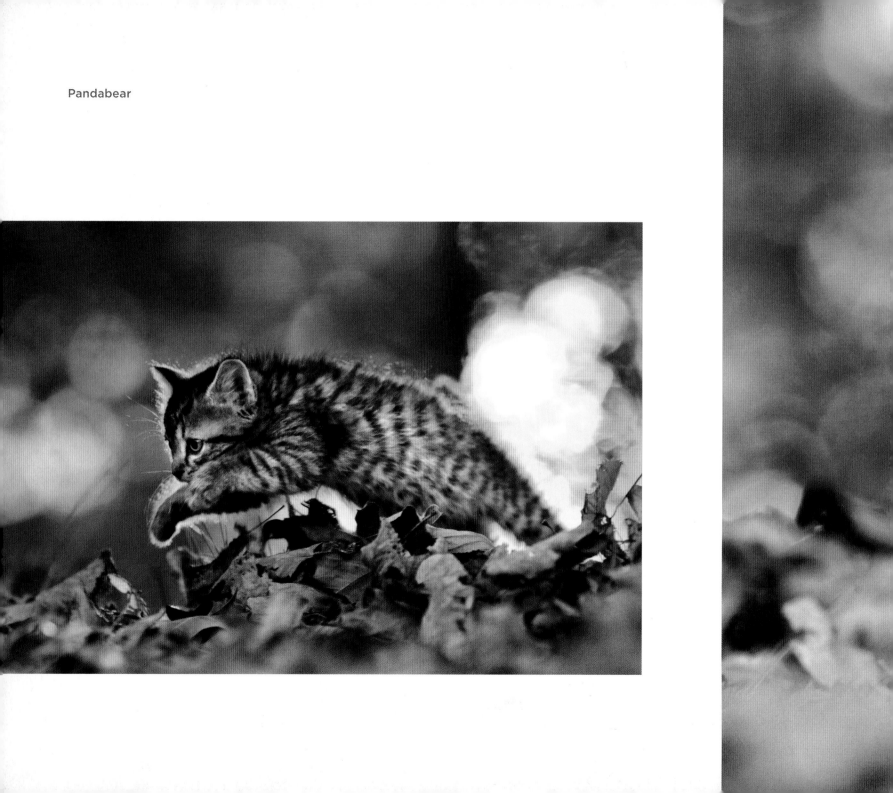

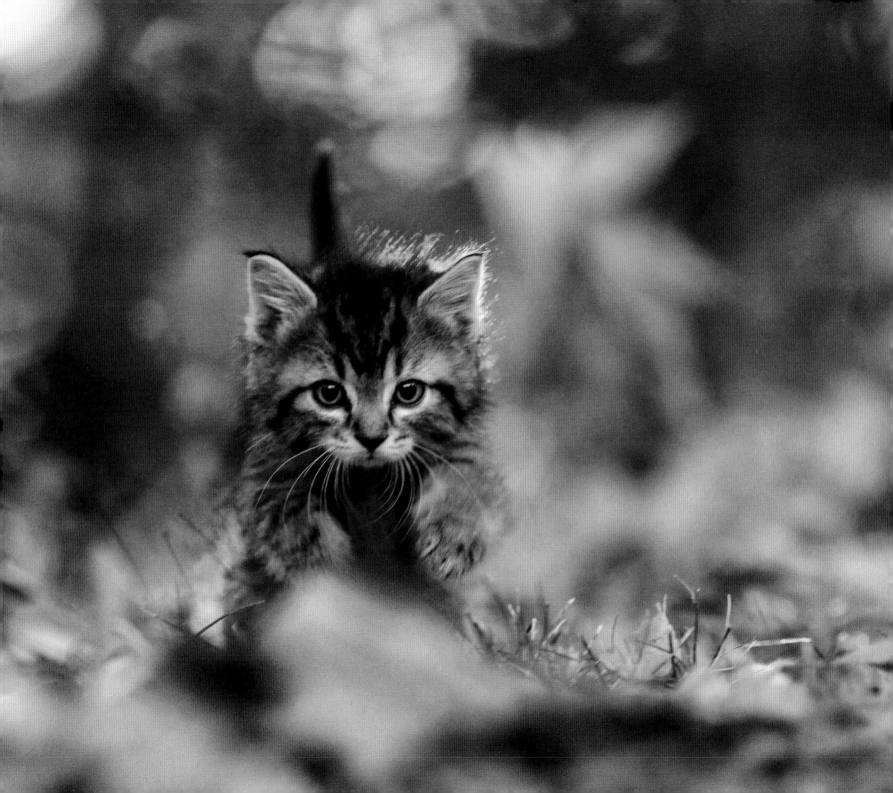

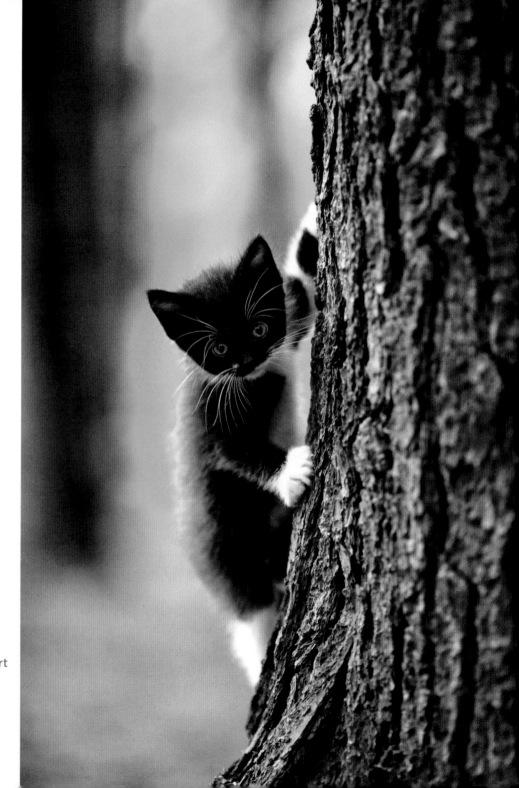

PopTart

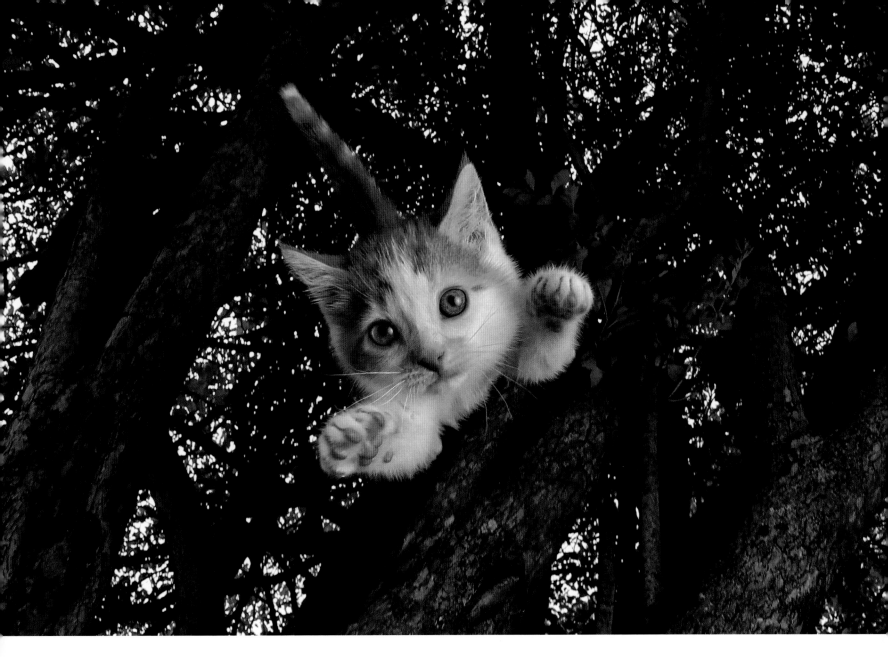

Jennifer

Froggie

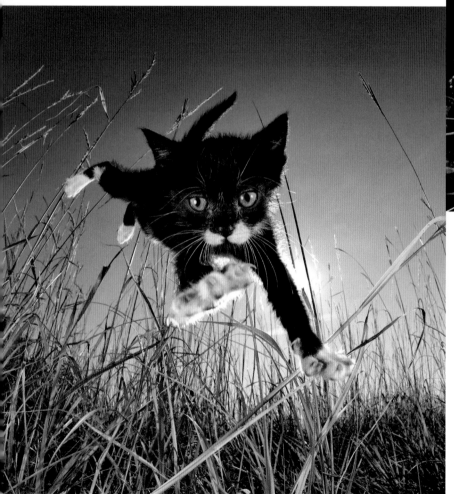

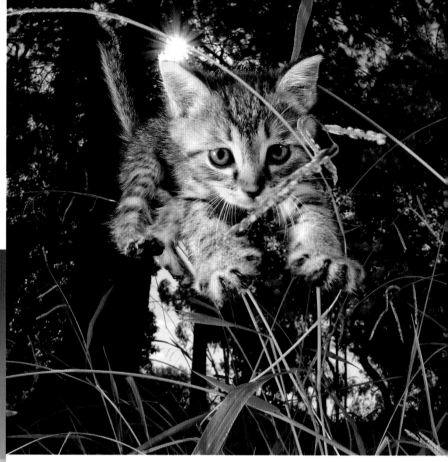

Sparkles

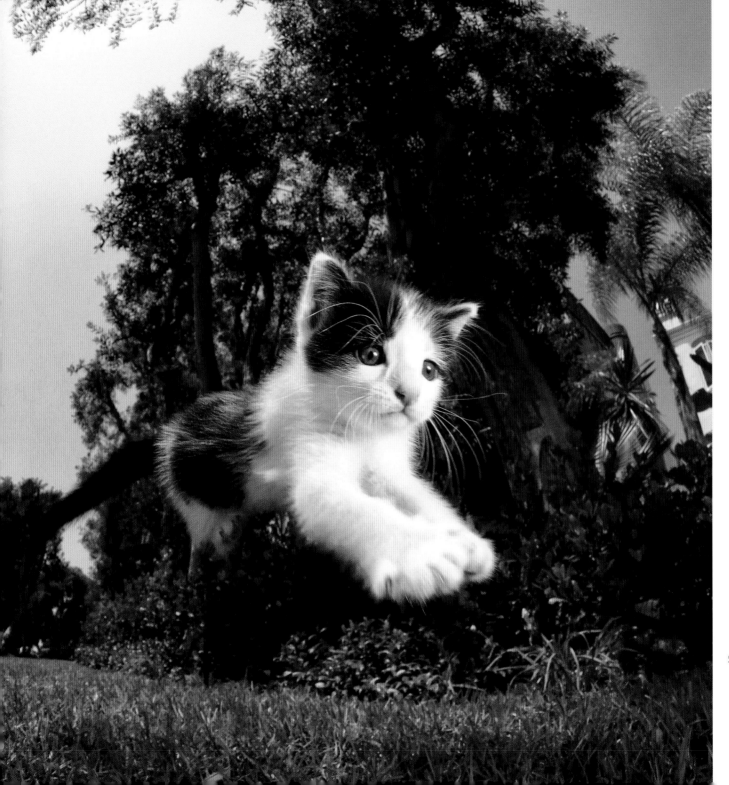

Solo

GummiBear

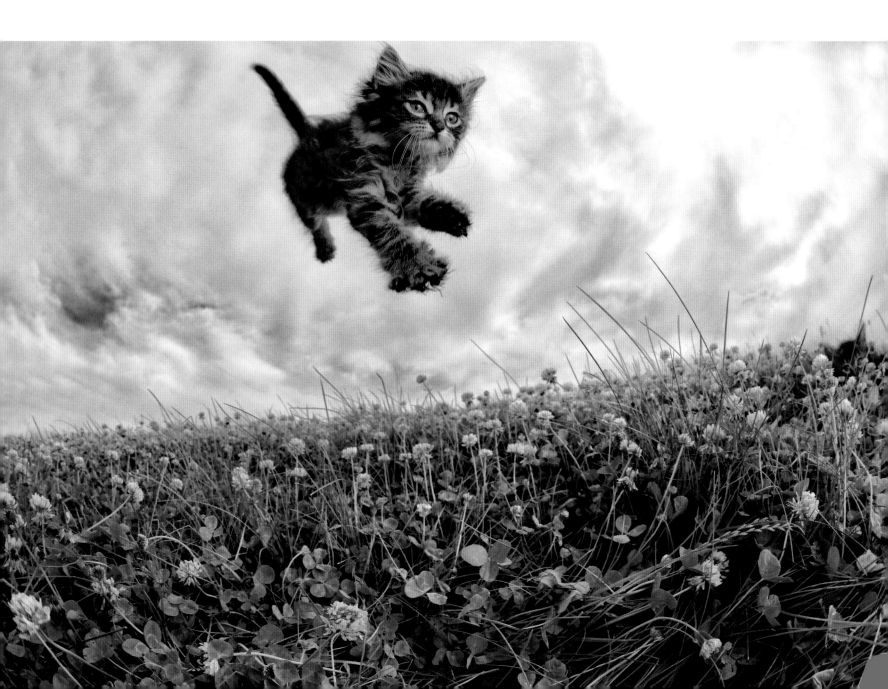

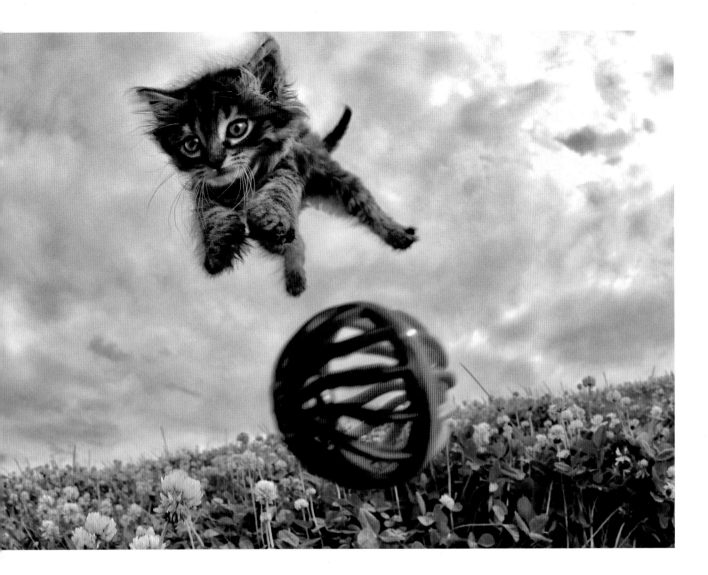

Fred Flintstone

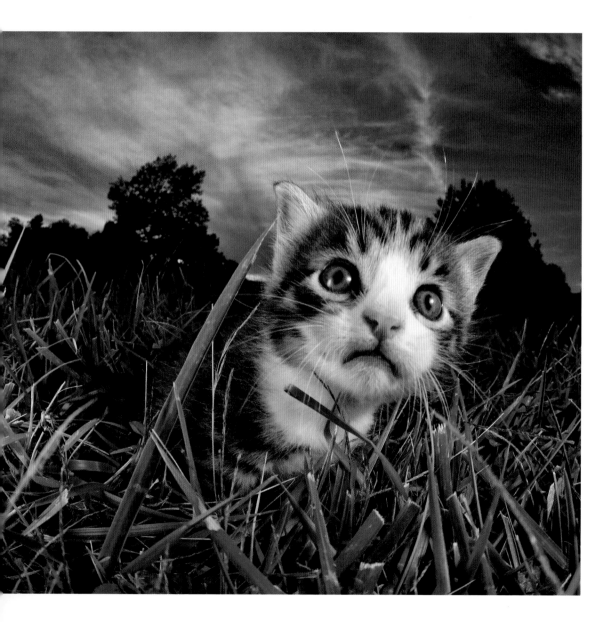

Chicken

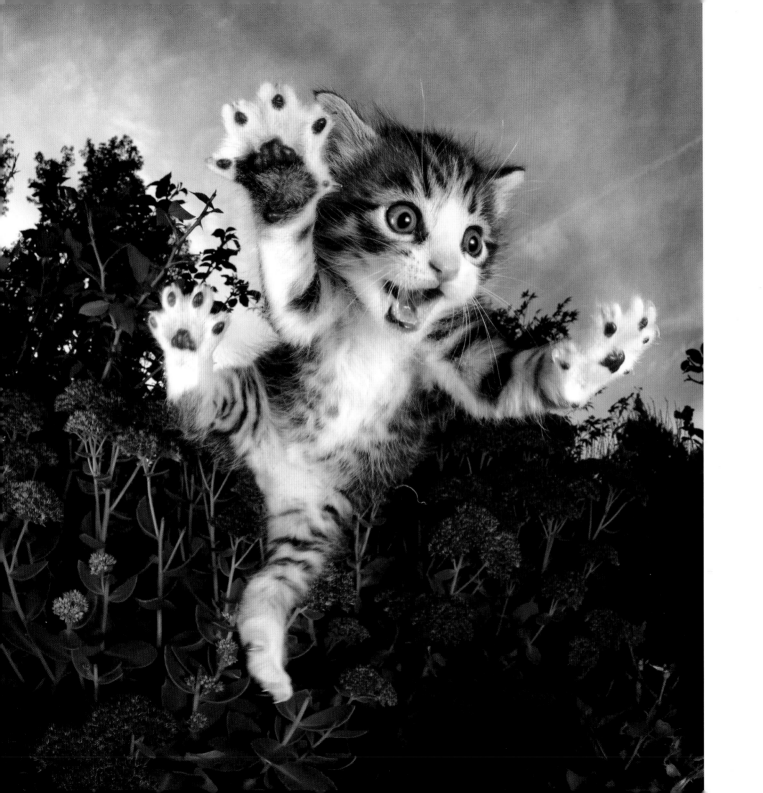

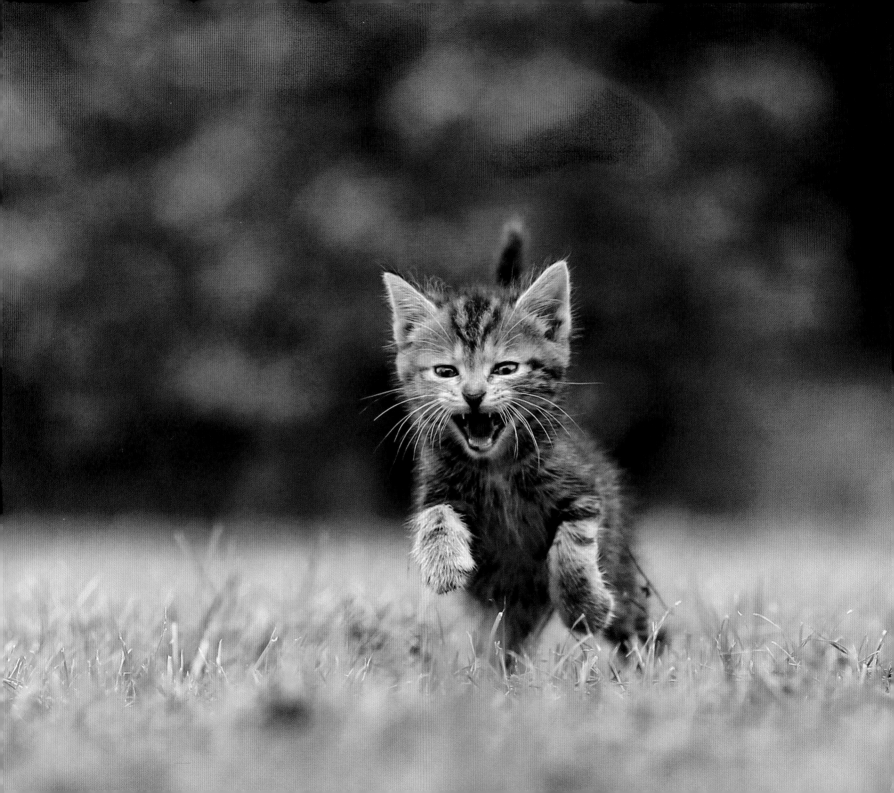

Yoda

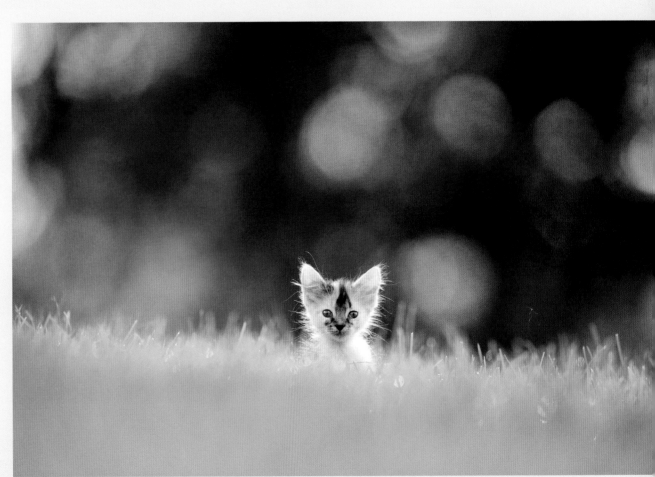

Stimpy

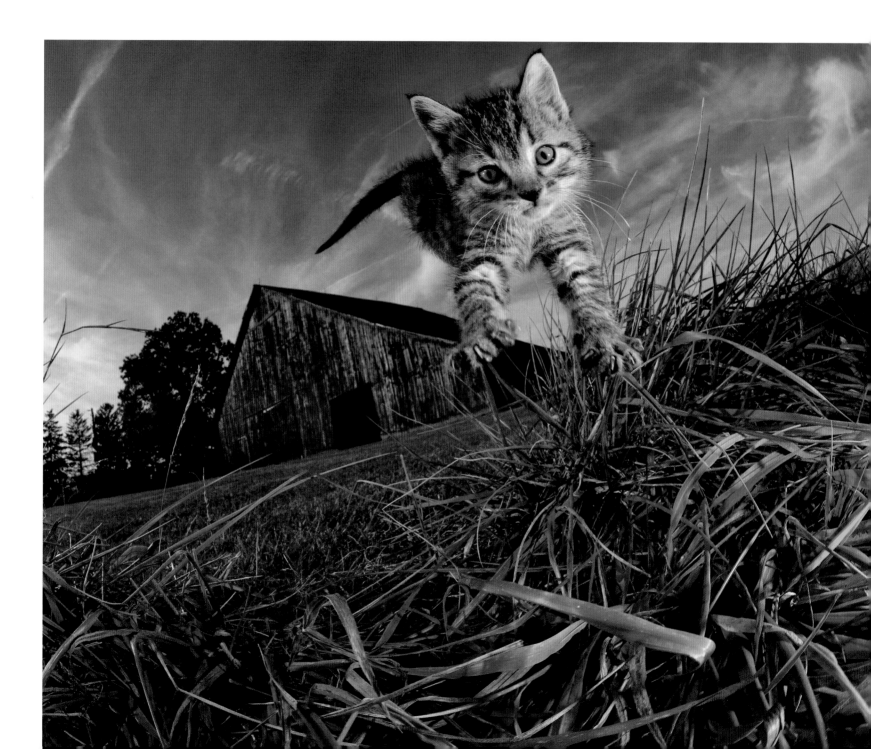

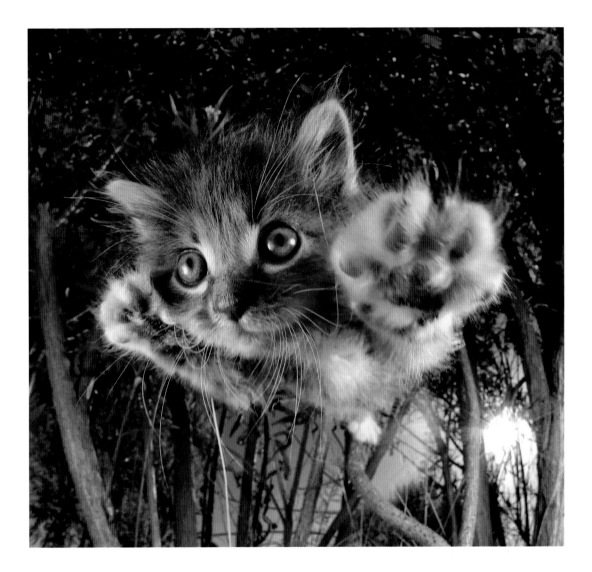

Sassy

Bamm-Bamm

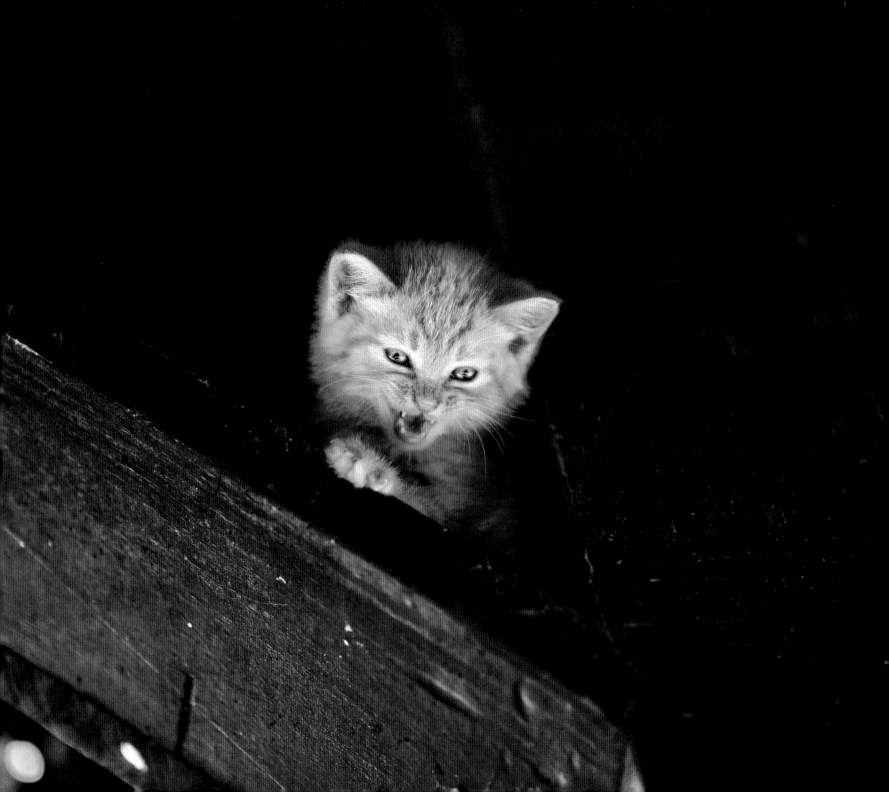

Wigglebop

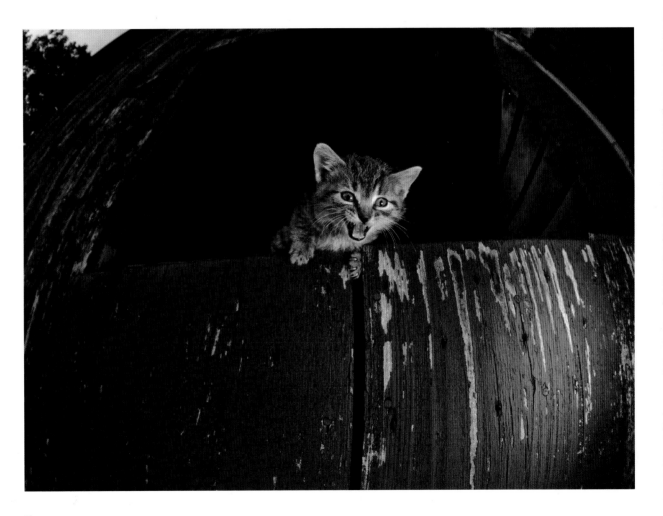

Sassy

Wigglebop

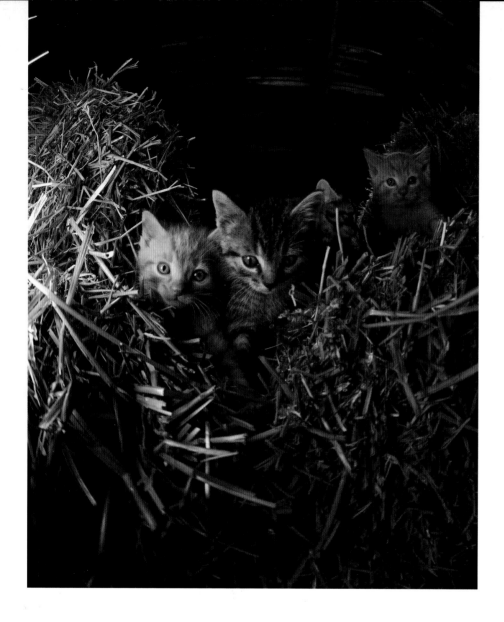

Wigglebop & Friends

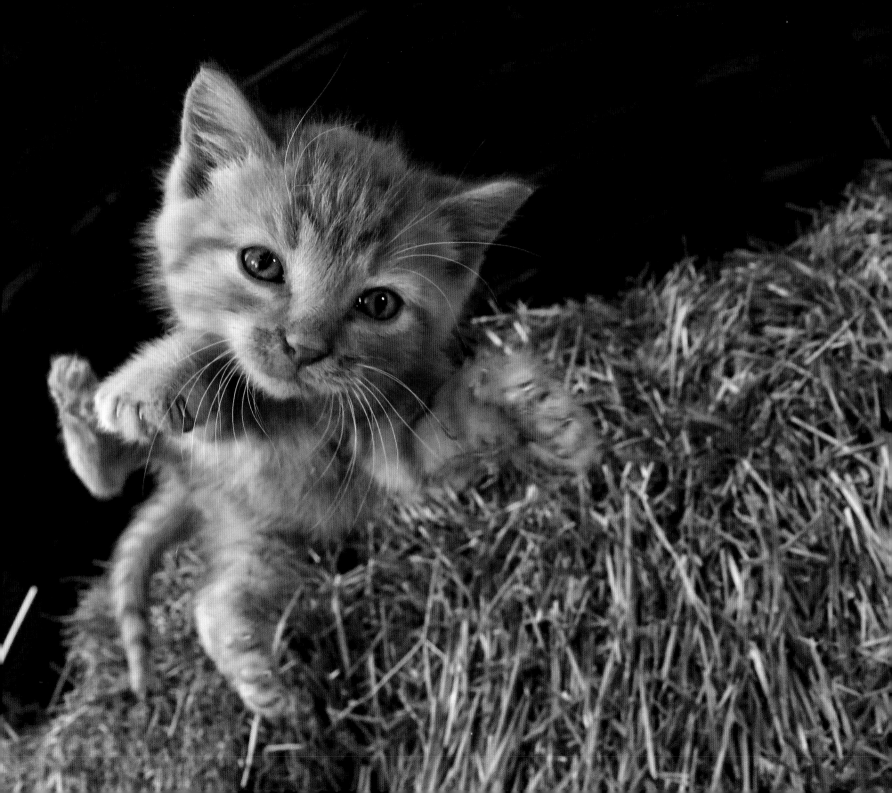

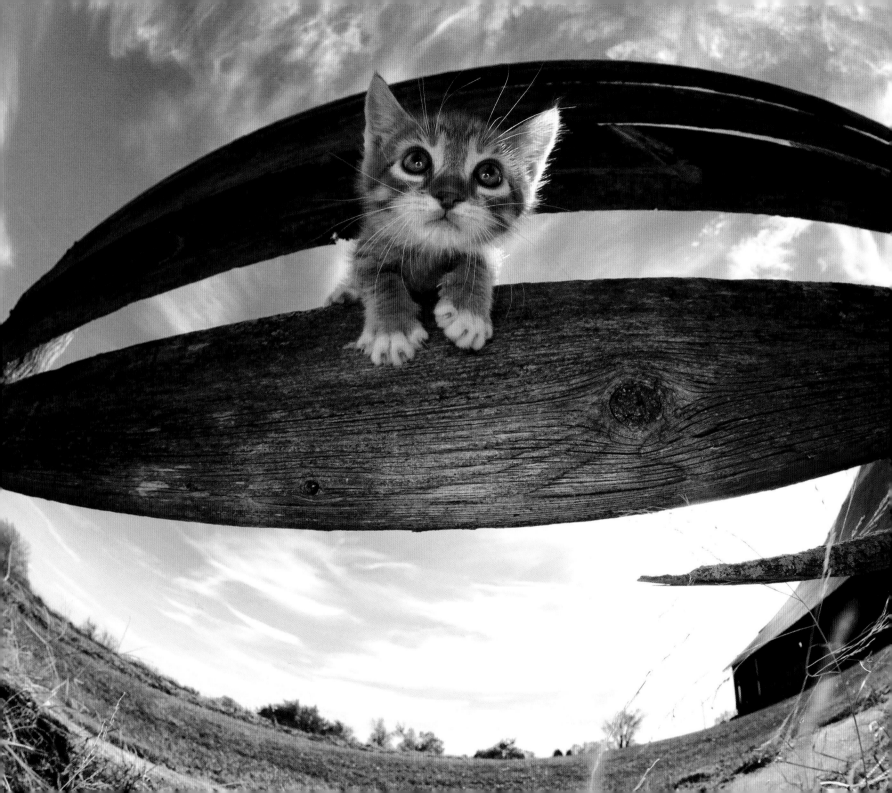

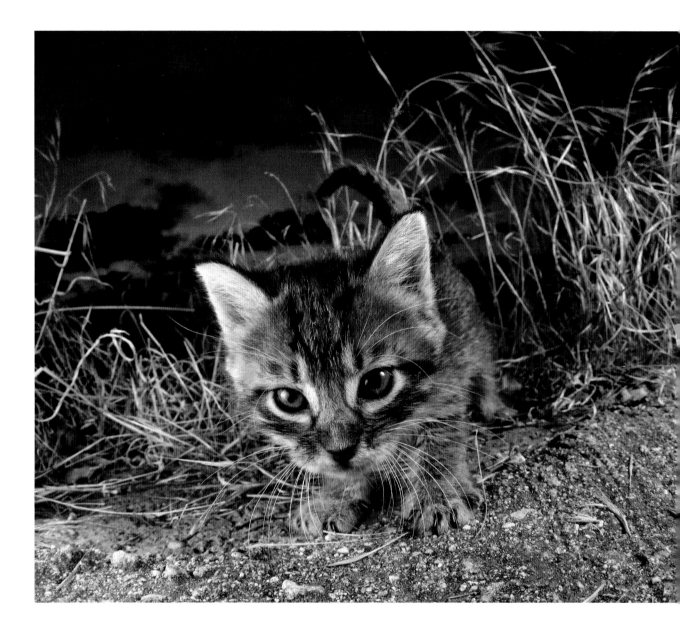

Bamm-Bamm

Captain Snuggles

Fuzzbucket

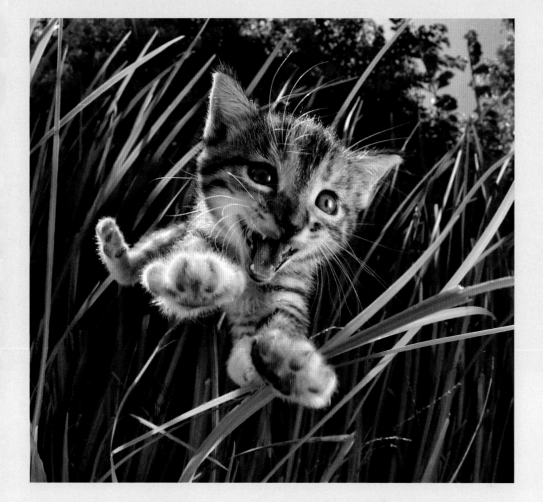

Bobblehead

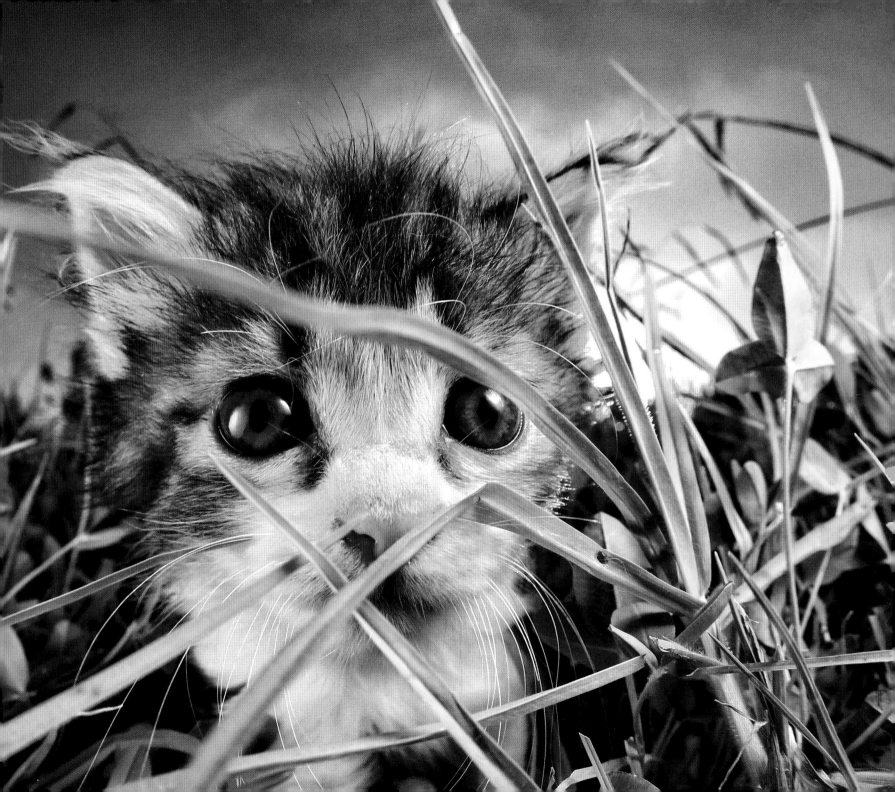

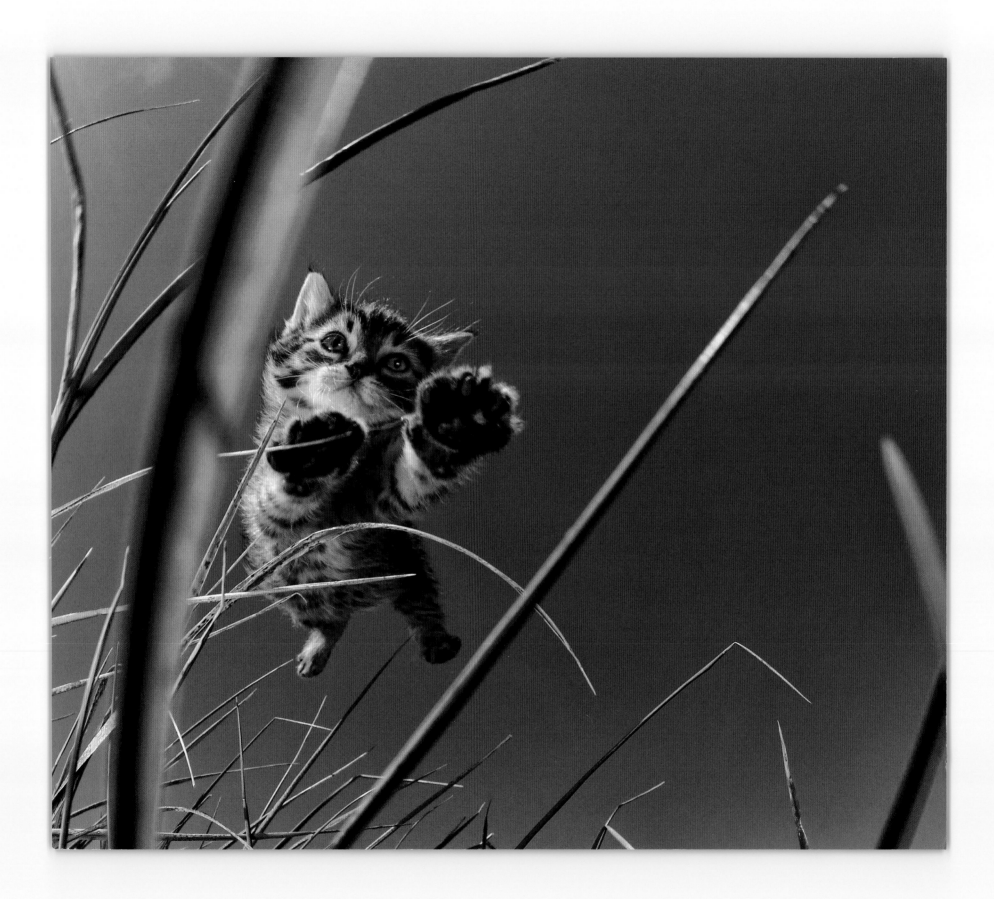

Bitsy

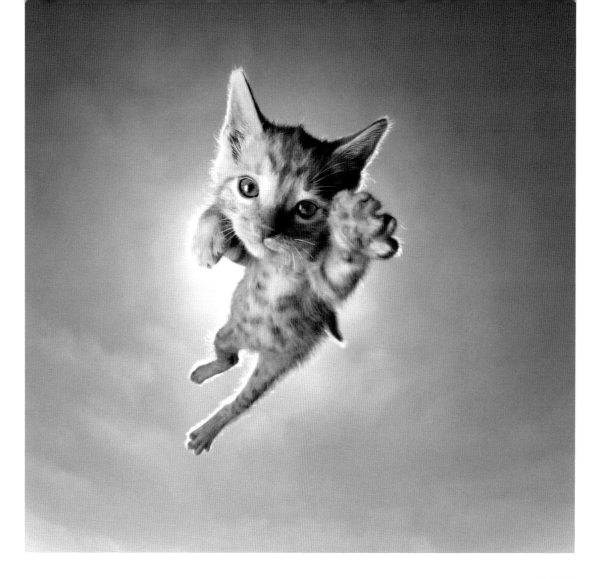

Peeps

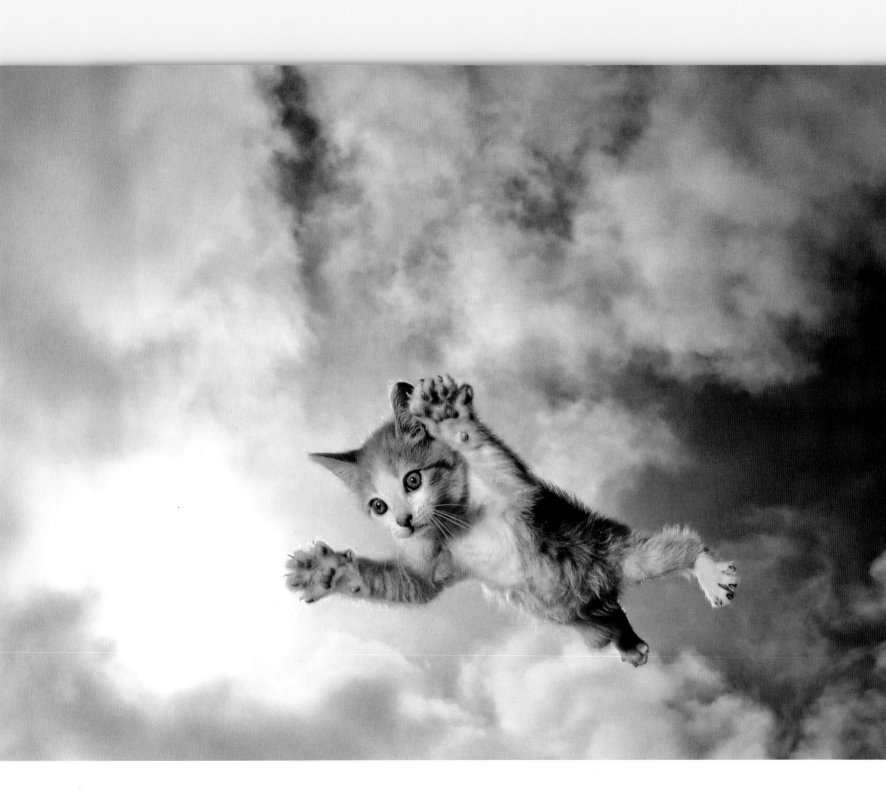

Bieber

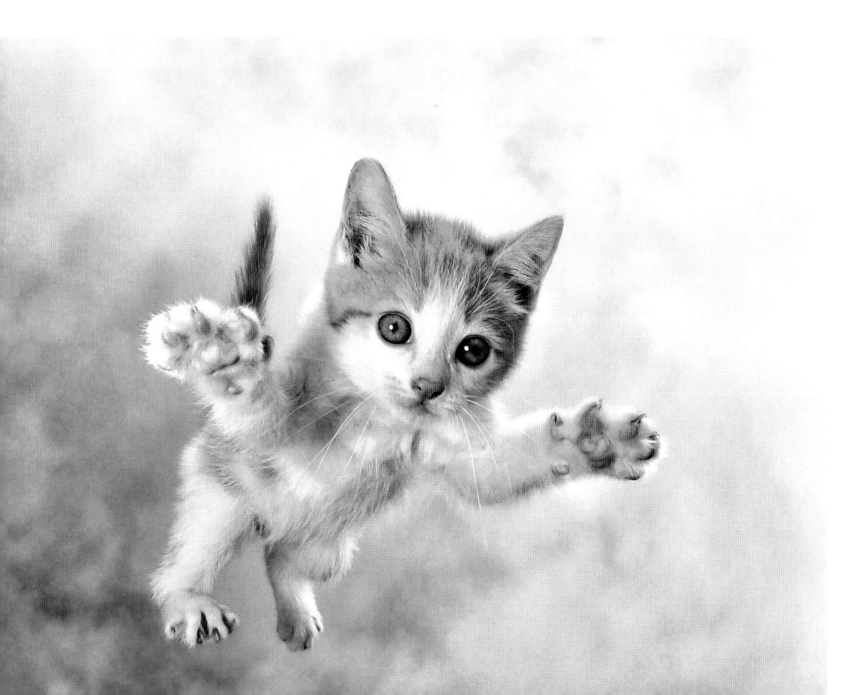

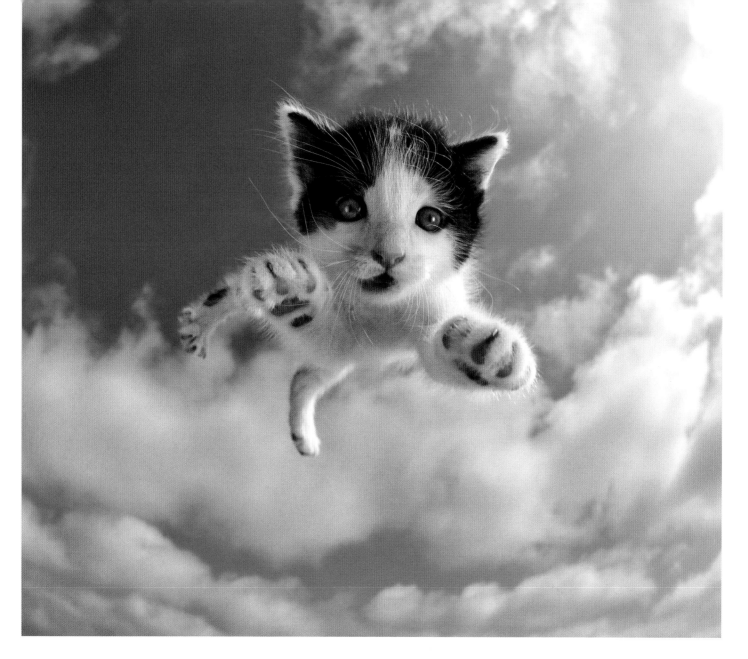

Tippy

Fuzzbucket

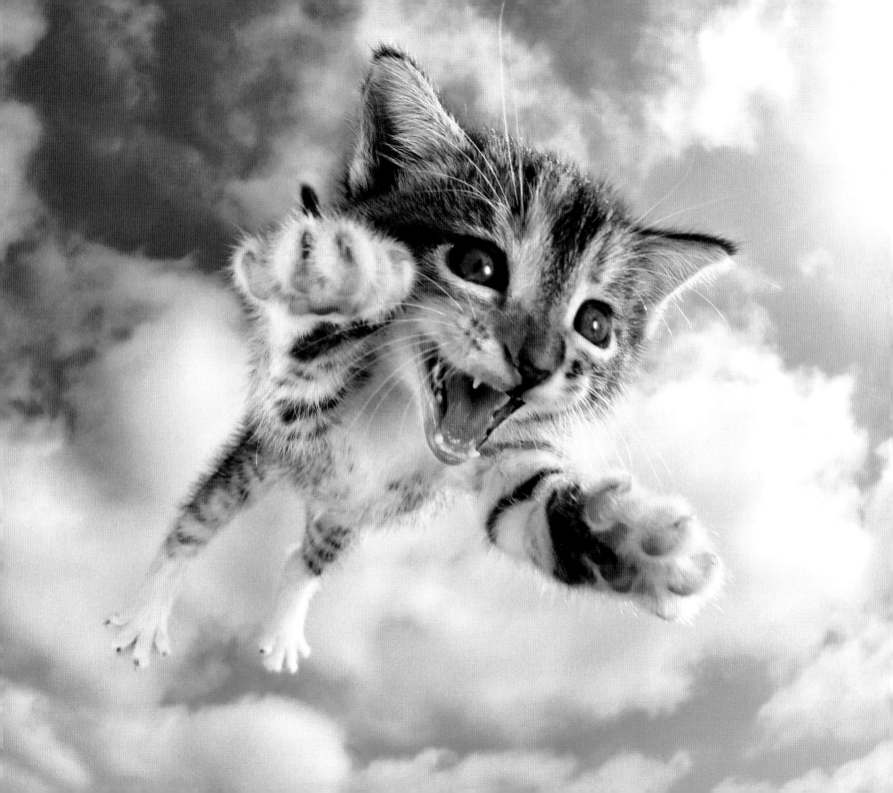

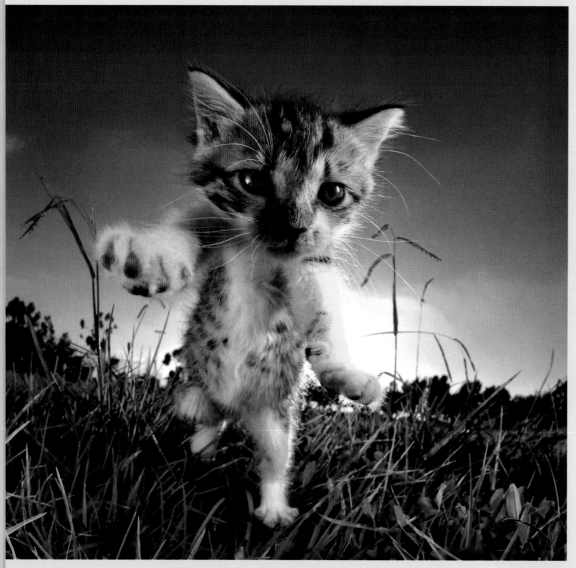

Twerky-butt

The Dud

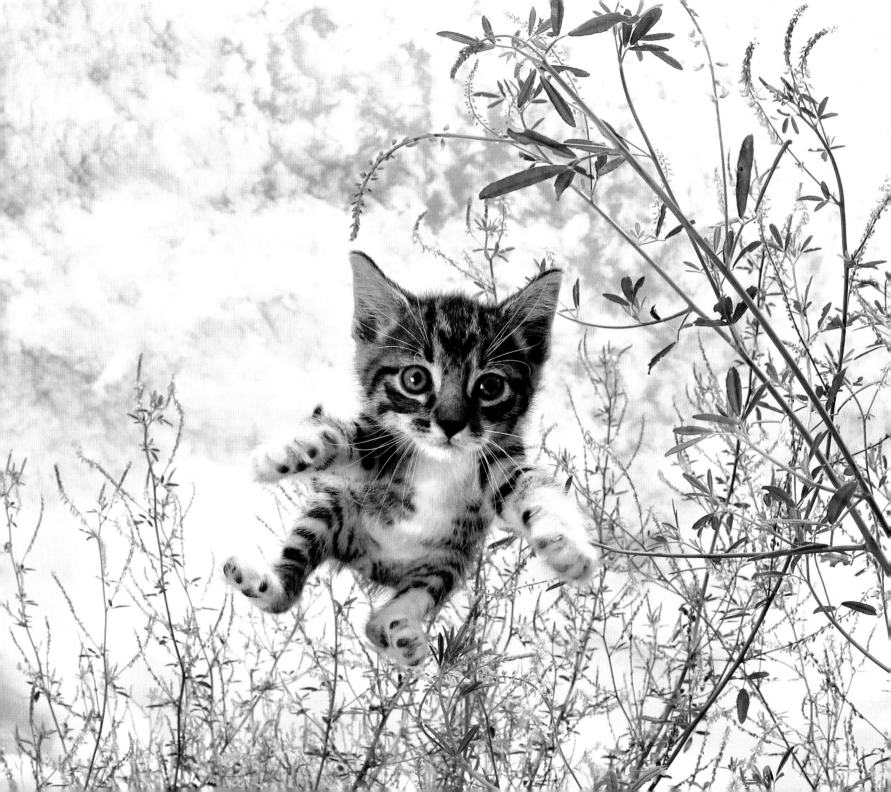

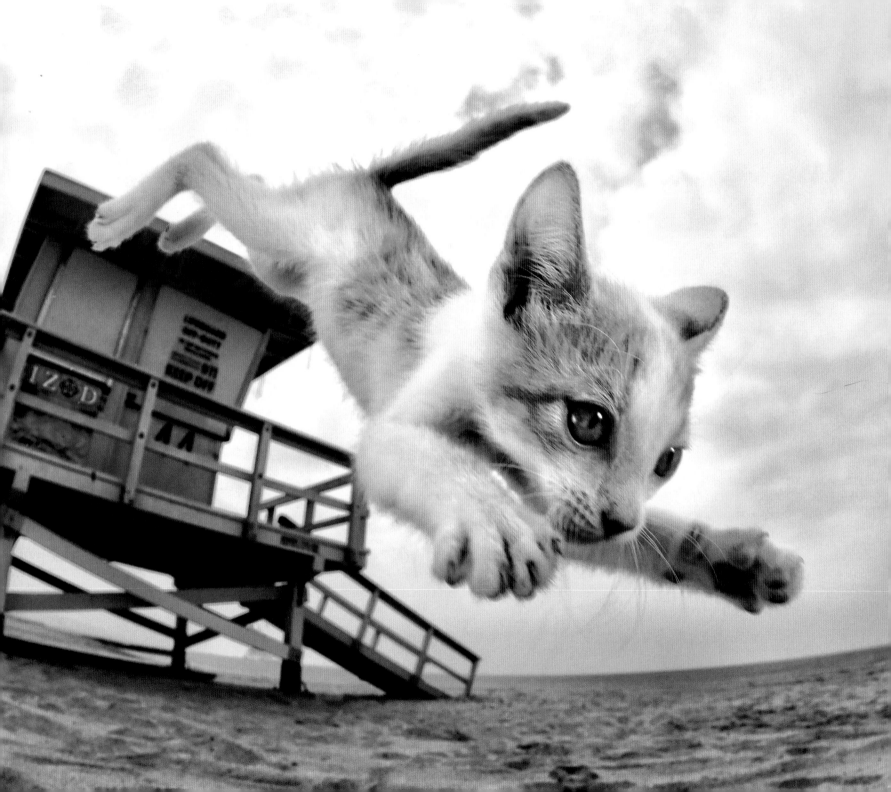

Frankenstein

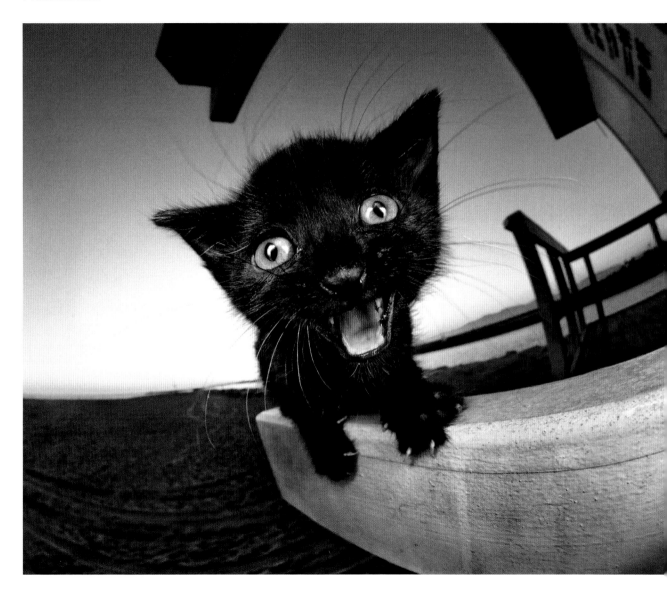

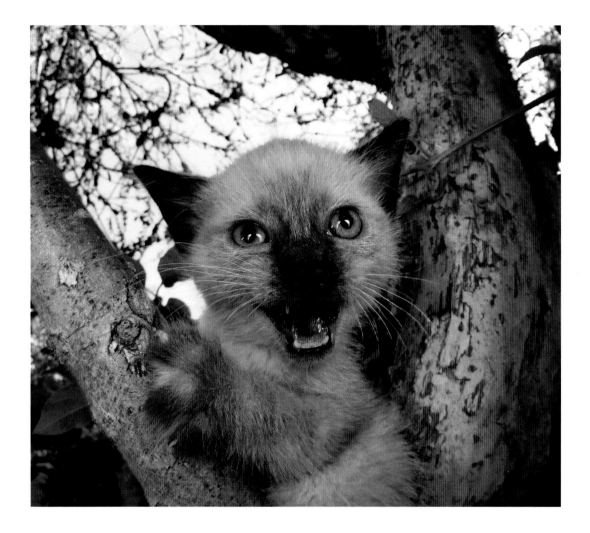

Winston

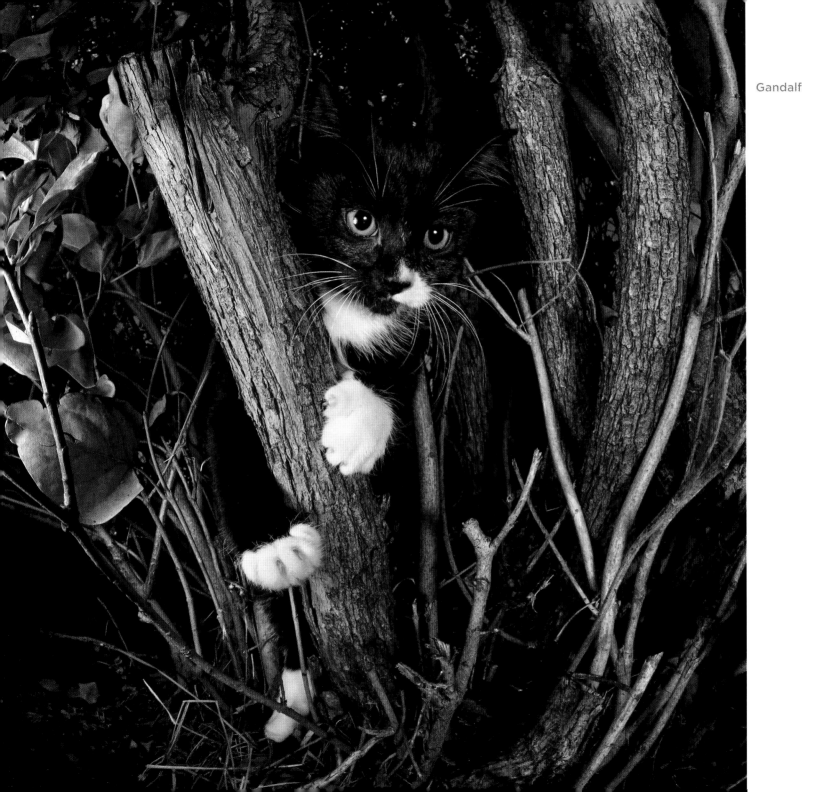

Gandalf

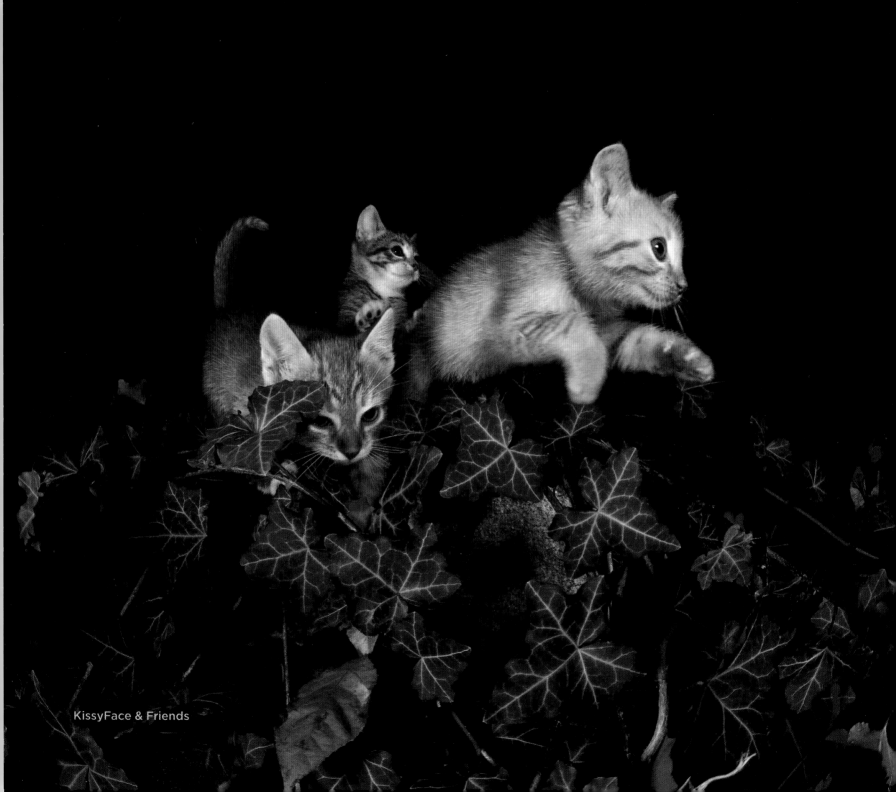

KissyFace & Friends

Tootsy-Wootsy & Friends

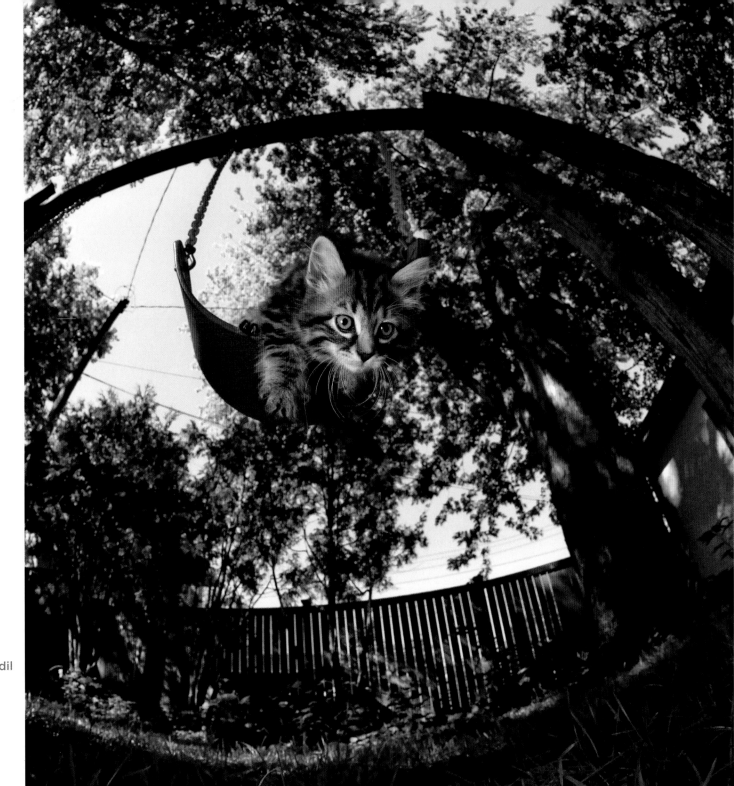

Daffodil

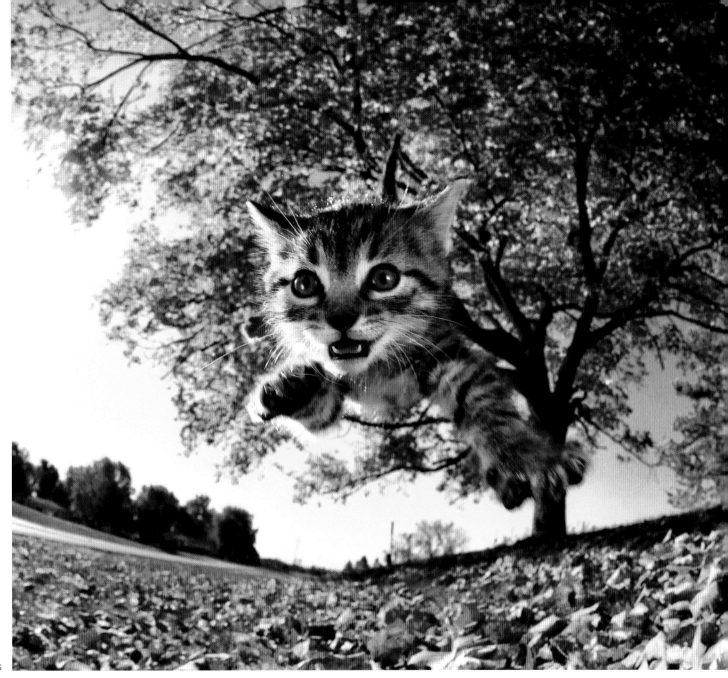

Edward Scissorpaws

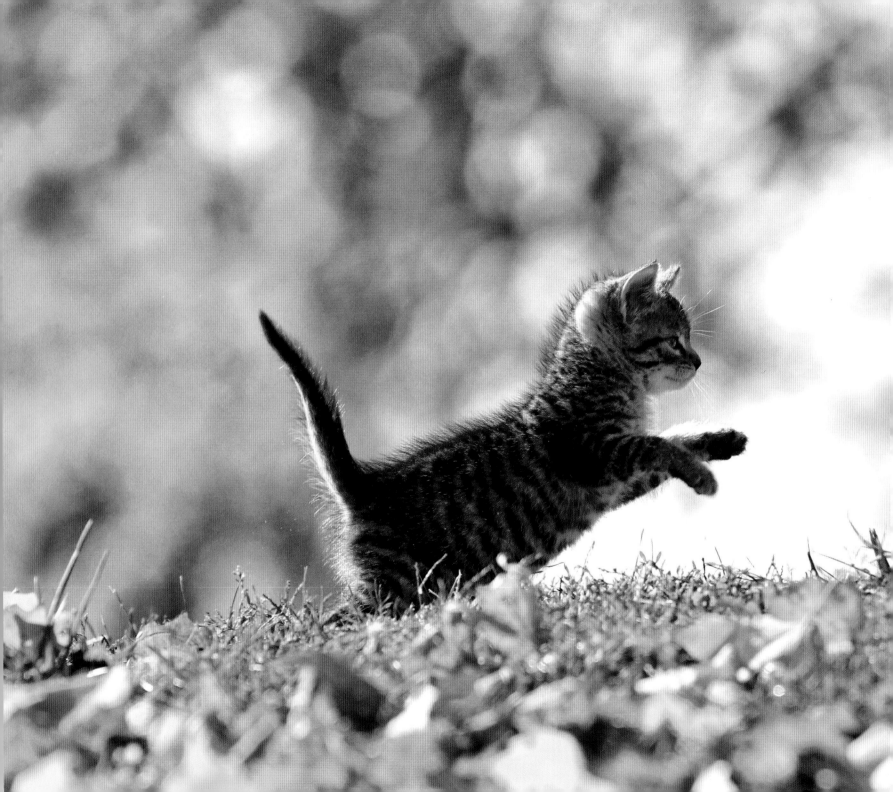

BooBoo

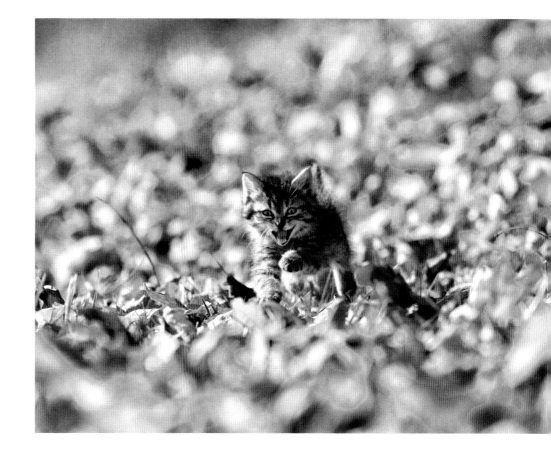

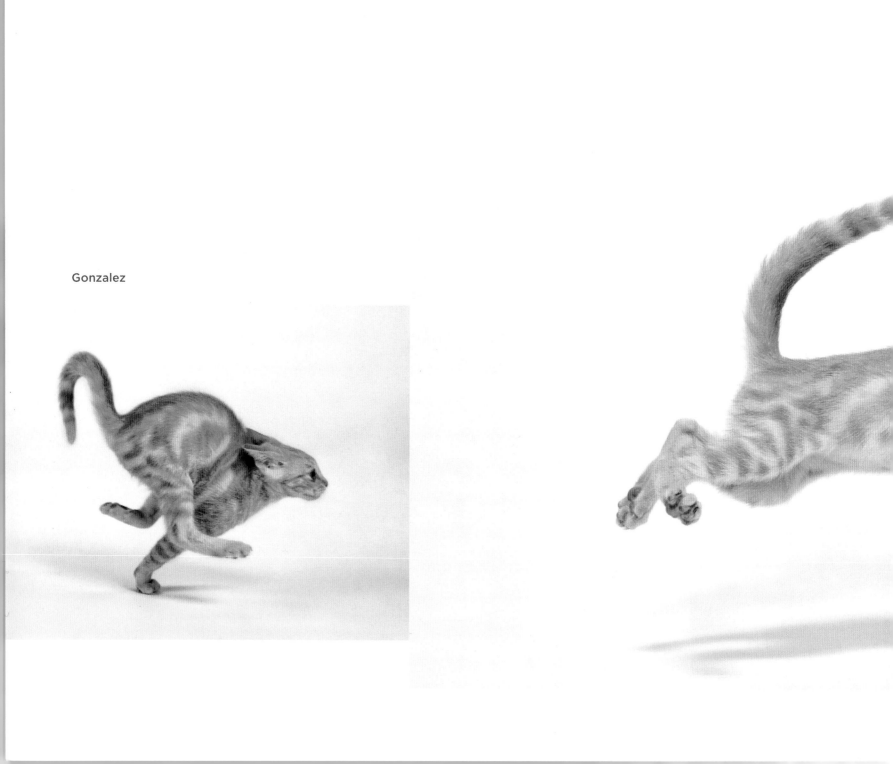

Gonzalez

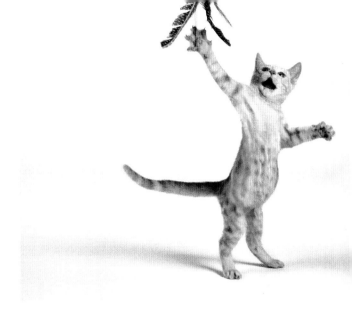
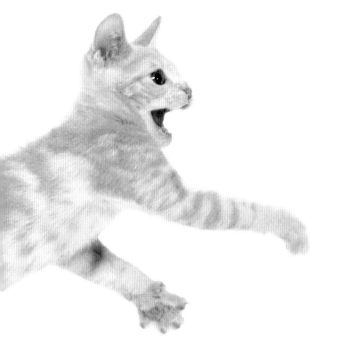

Tubmuffin

Petunia

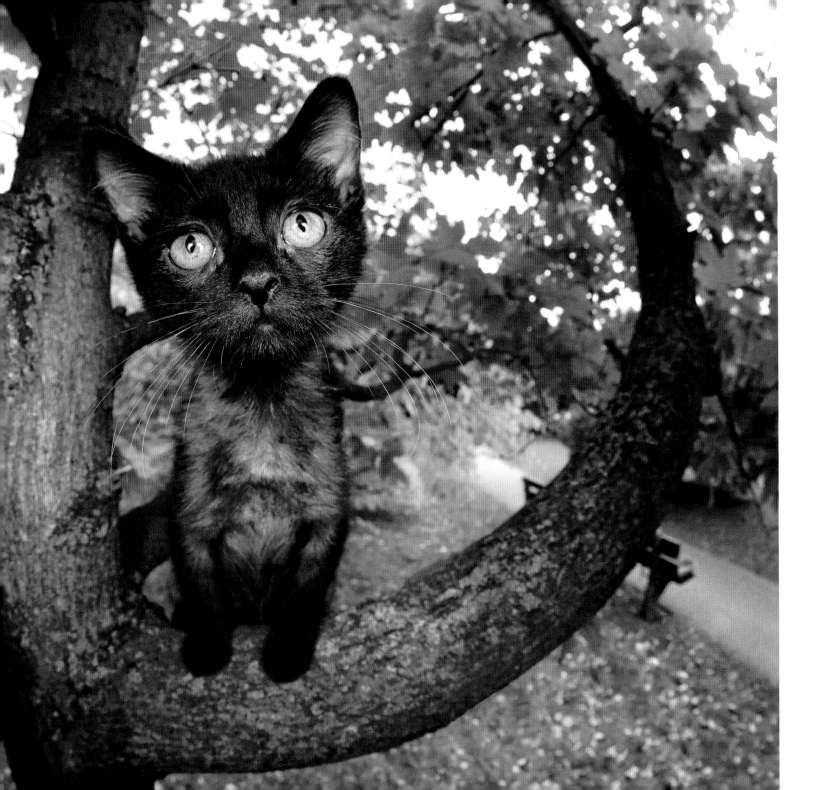

Gizmo

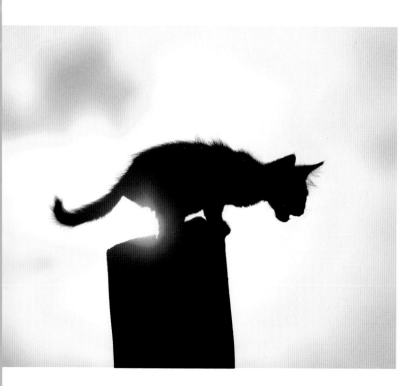

Zippy

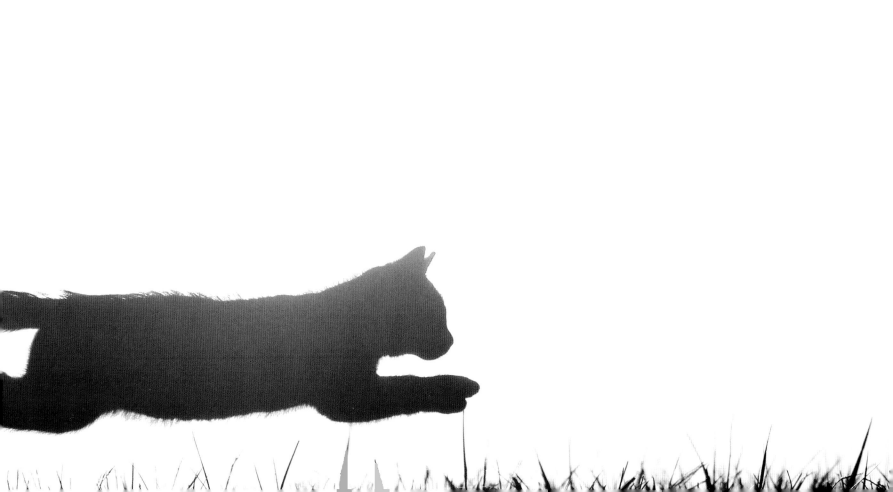

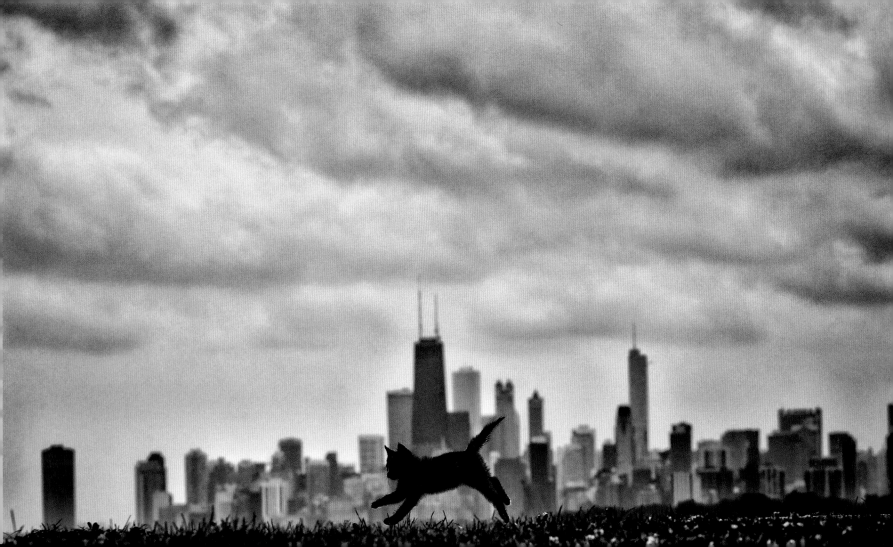

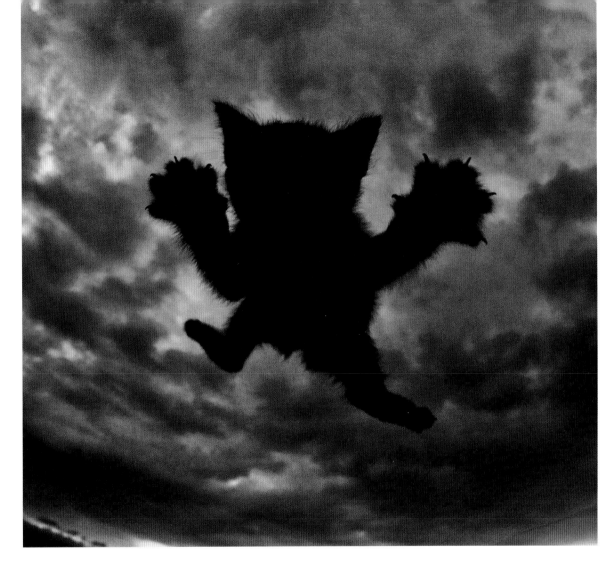

Tater Tot

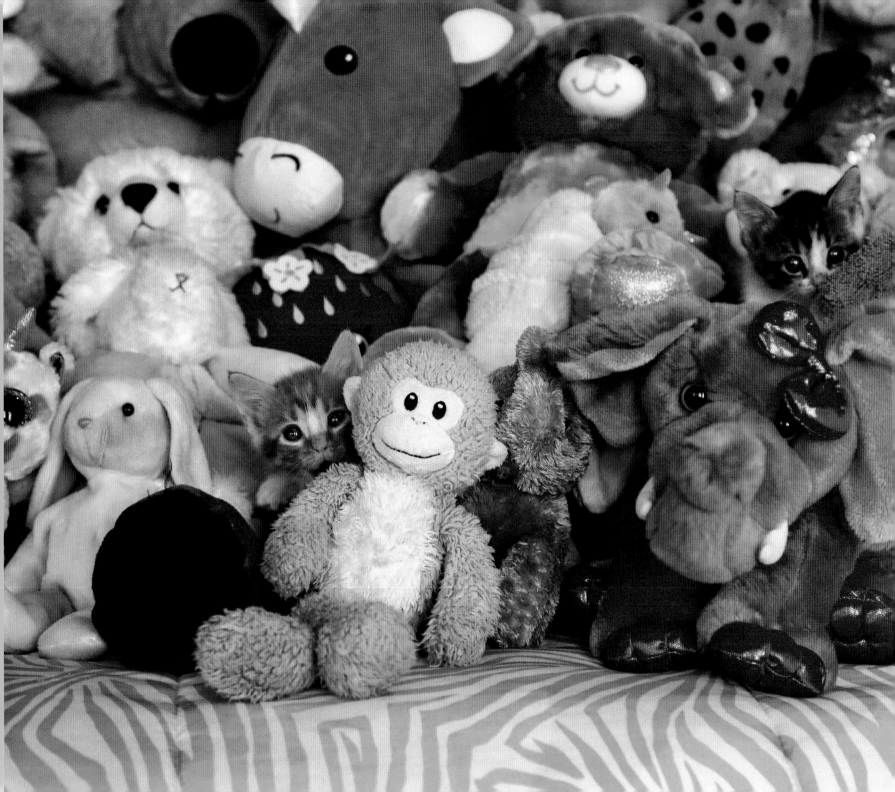

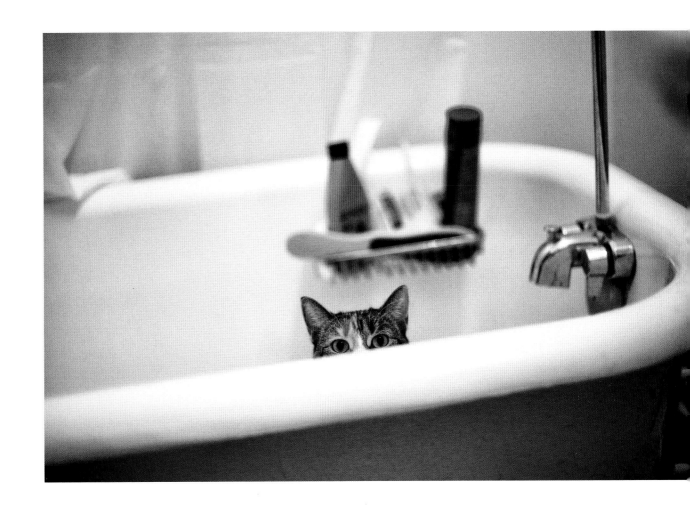

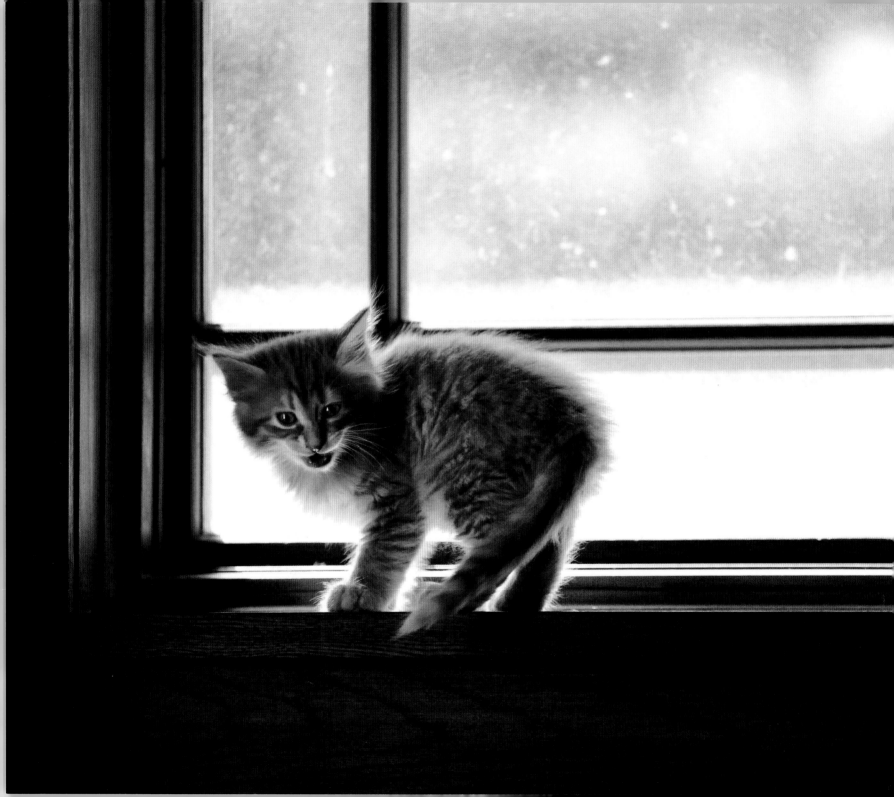

Furball

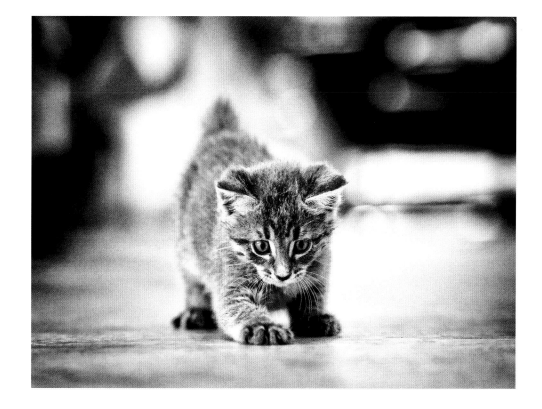

Captain Cookieface

Mr. Pillow

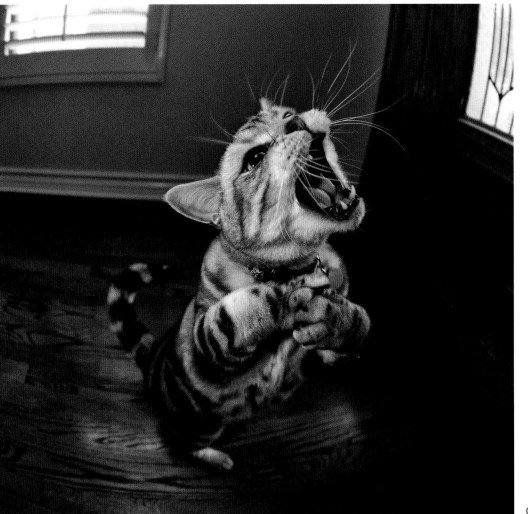

Crunch

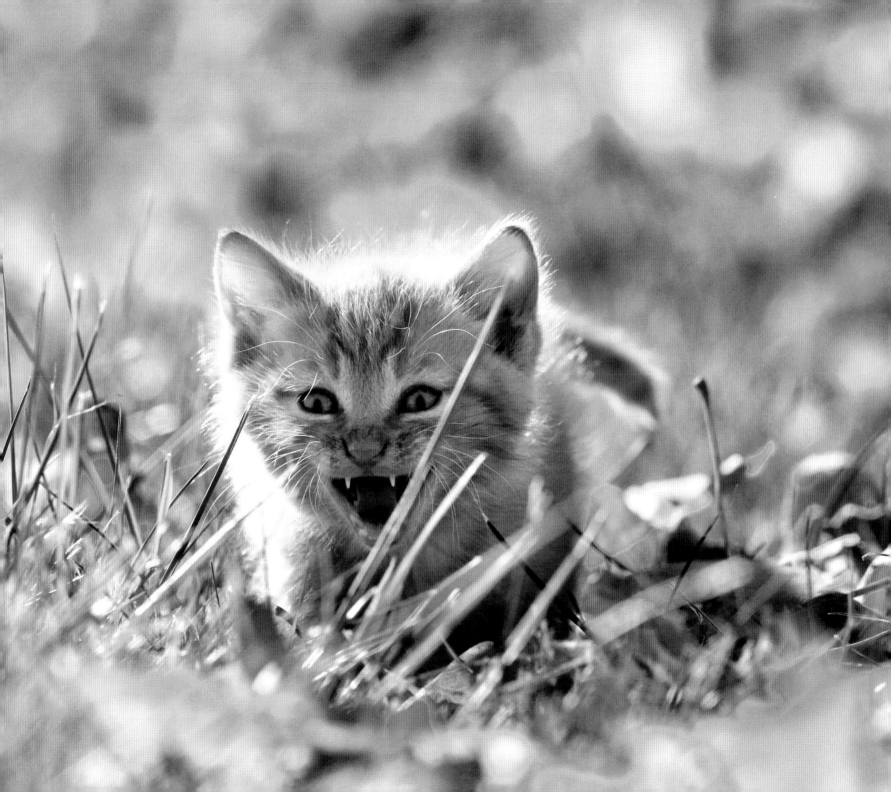

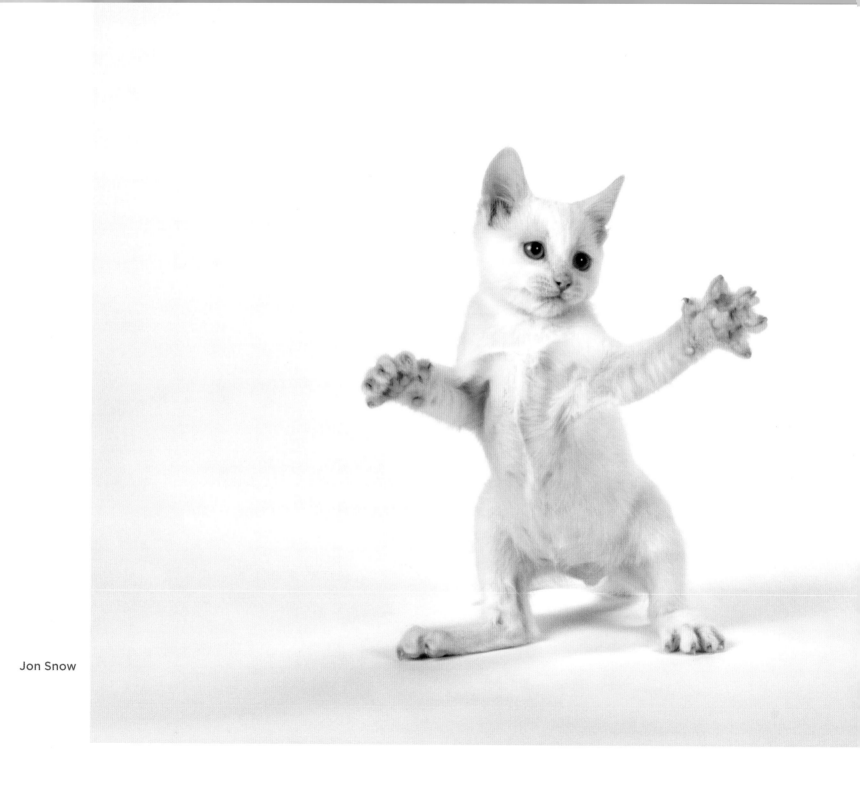

Jon Snow

Twinkletoes

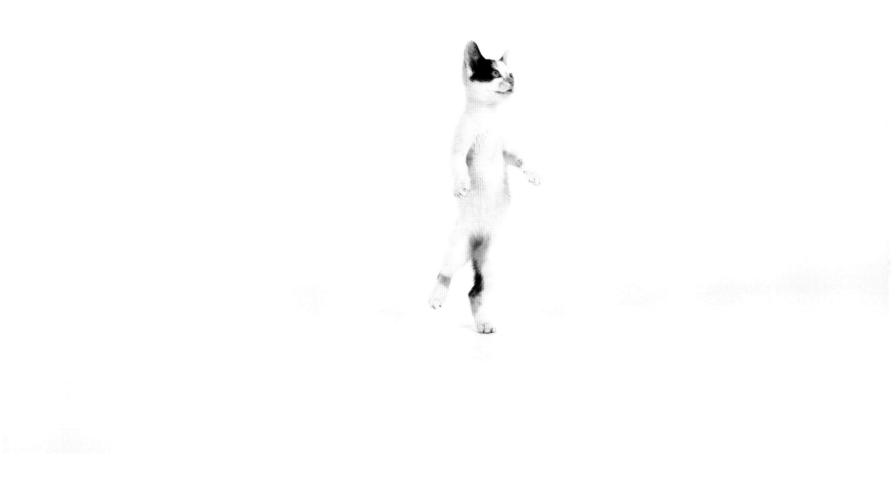

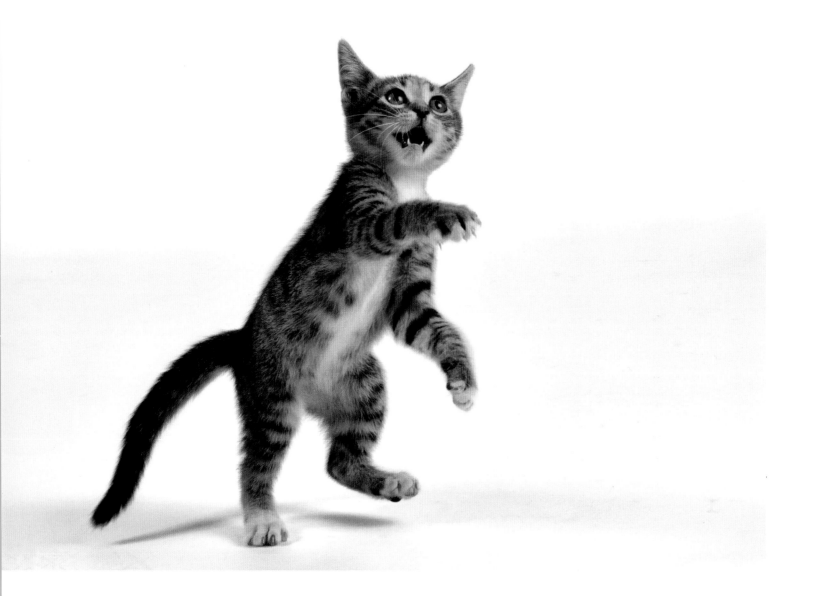

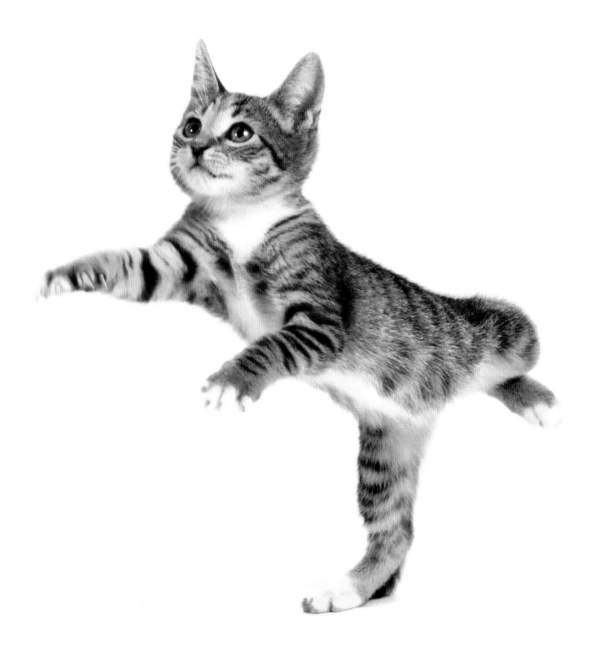

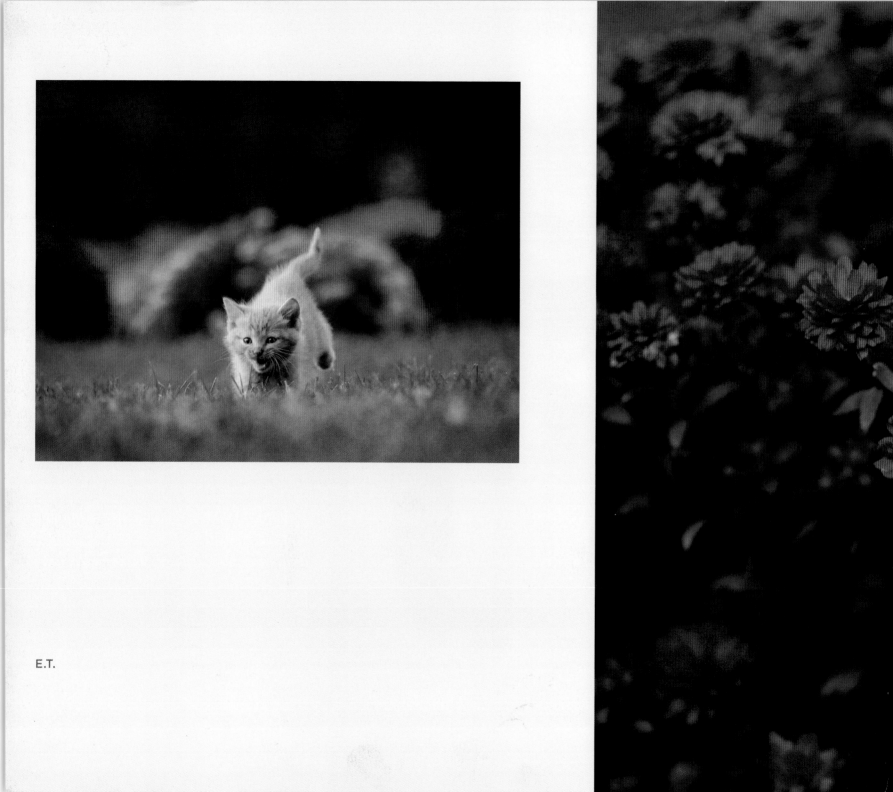

E.T.

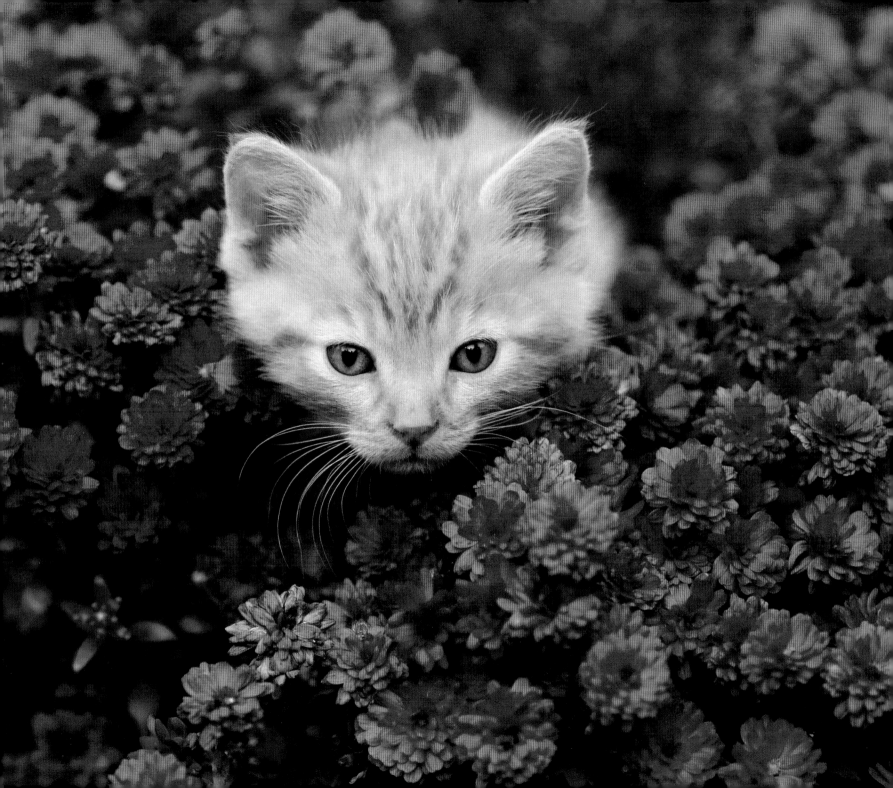

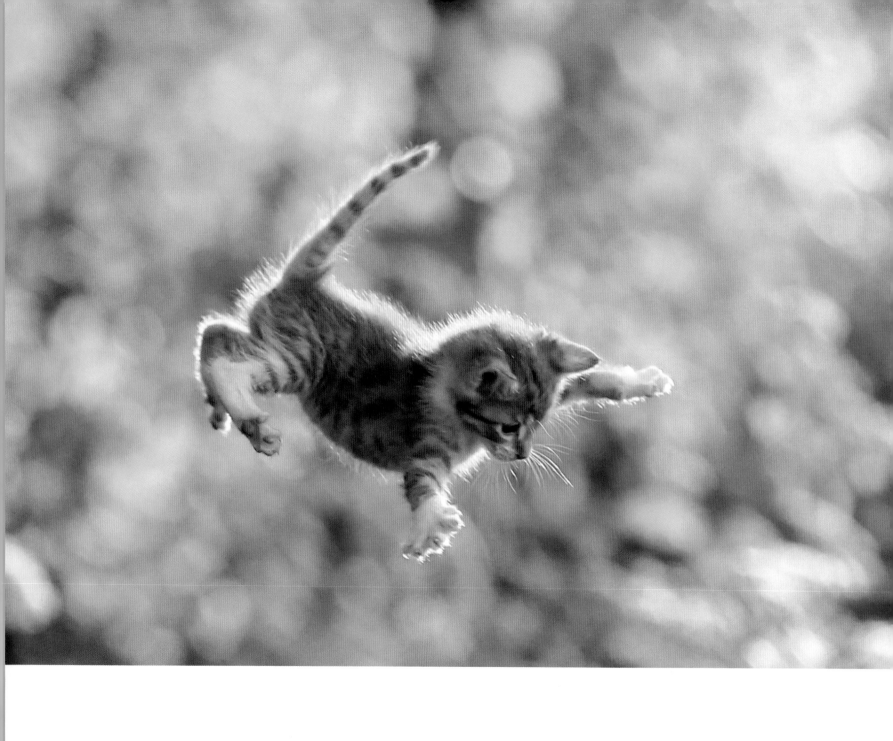

Kermit & Fozzie

SpongeBob

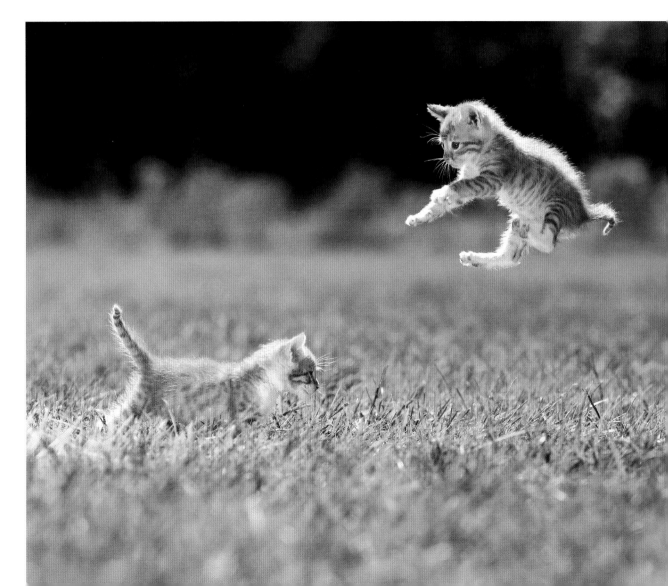

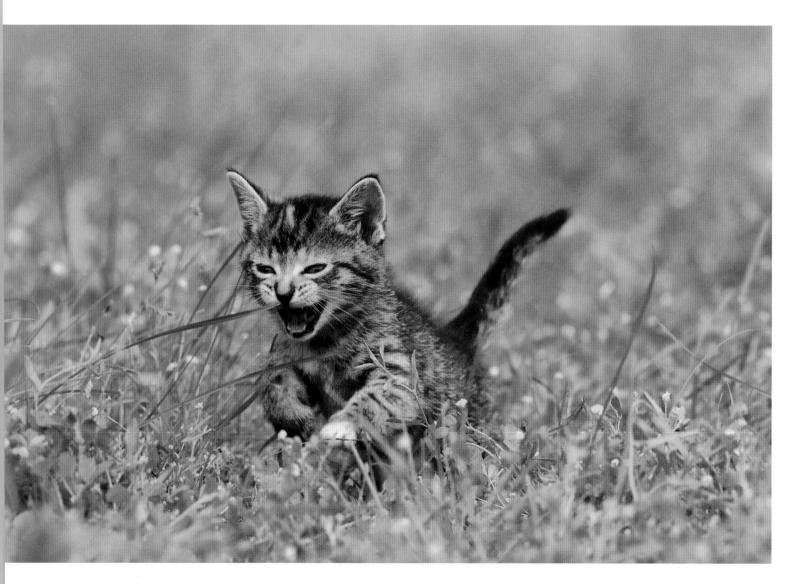

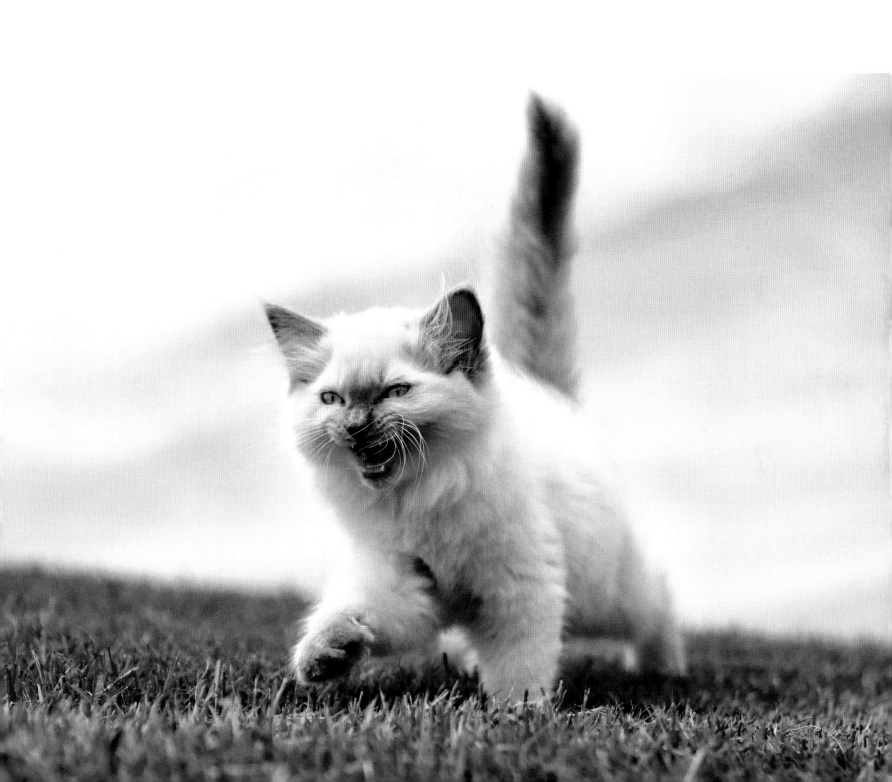

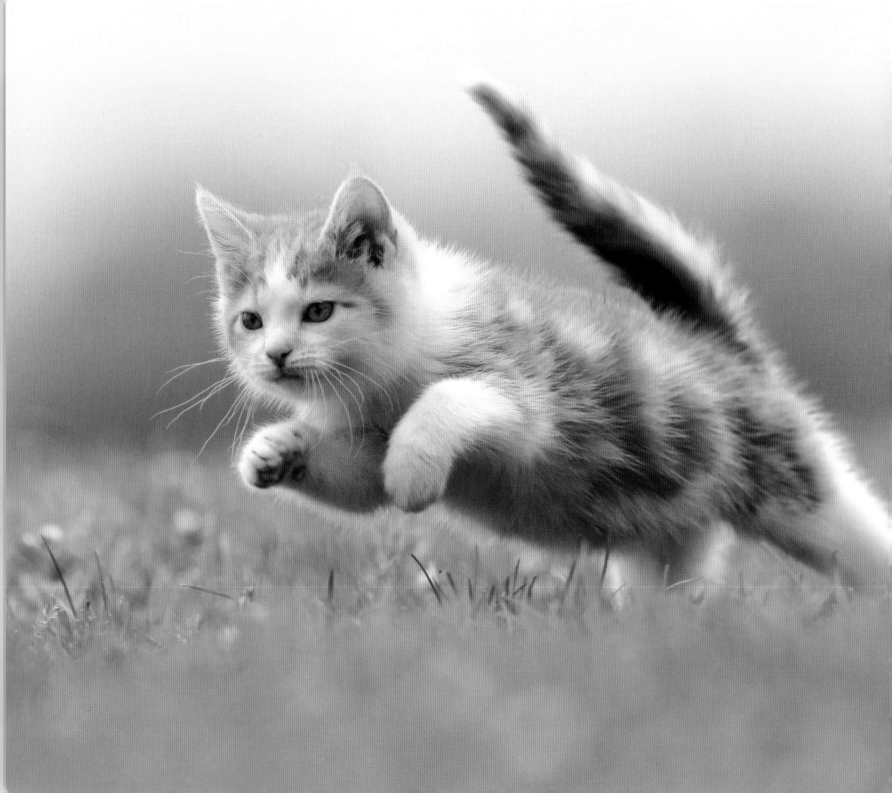

Geraldo

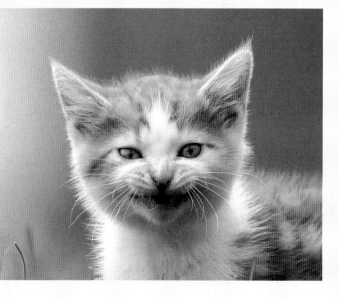

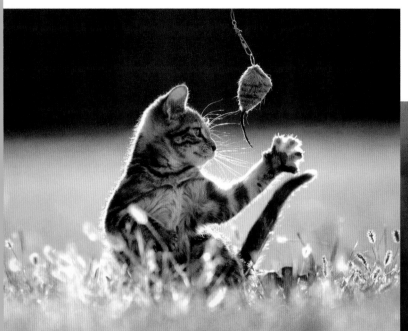

JellyBean

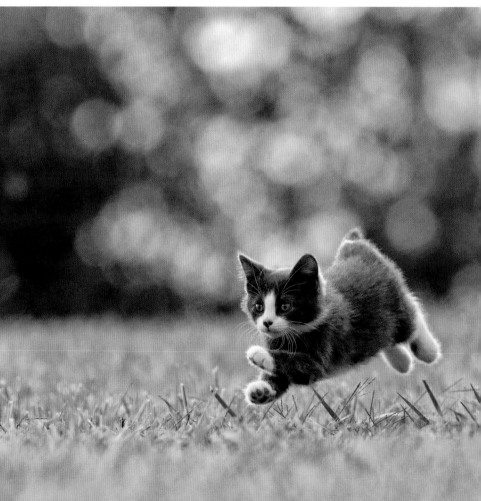

Fabio

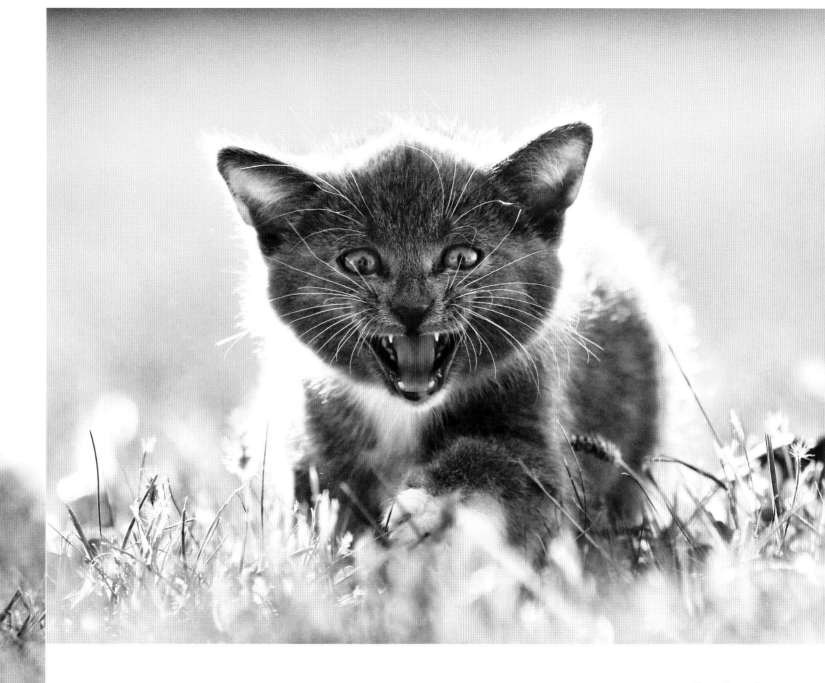

PapaSmurf

Fabio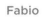

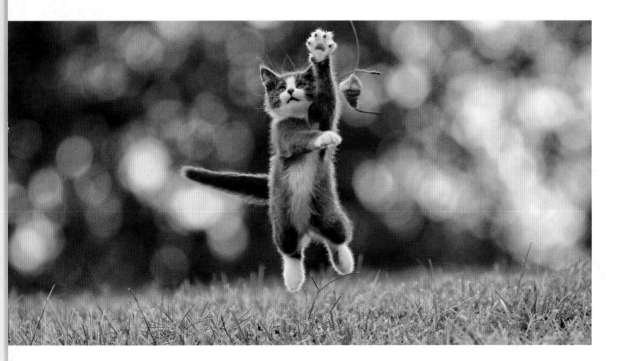

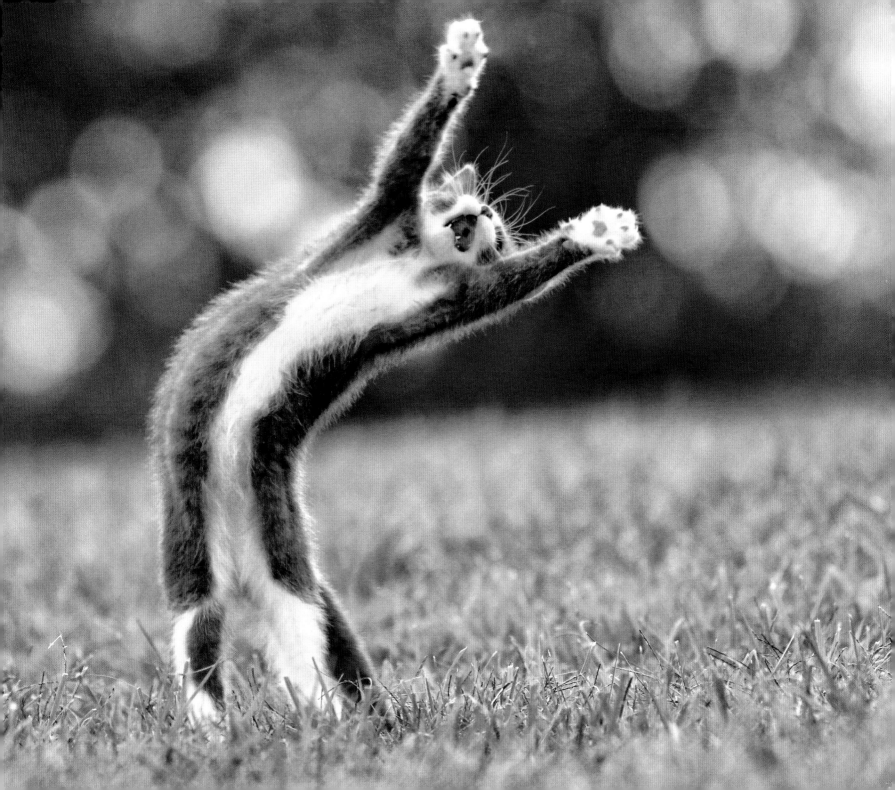

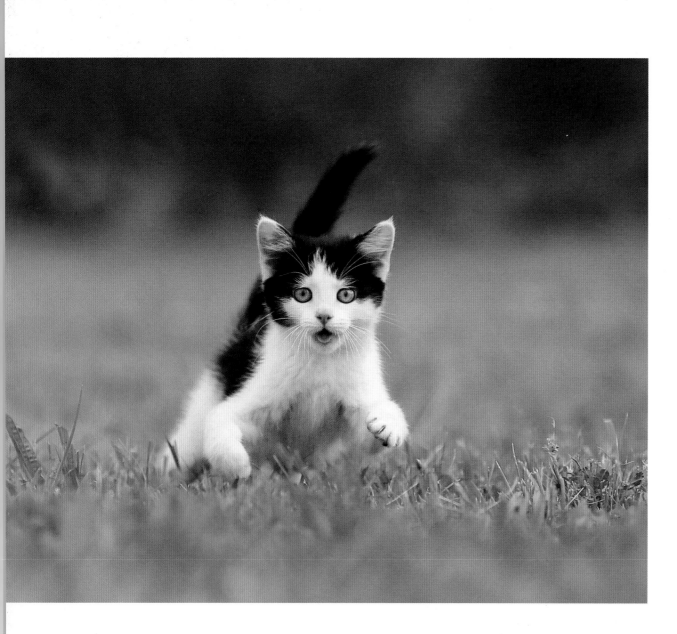

Sugar Smacks

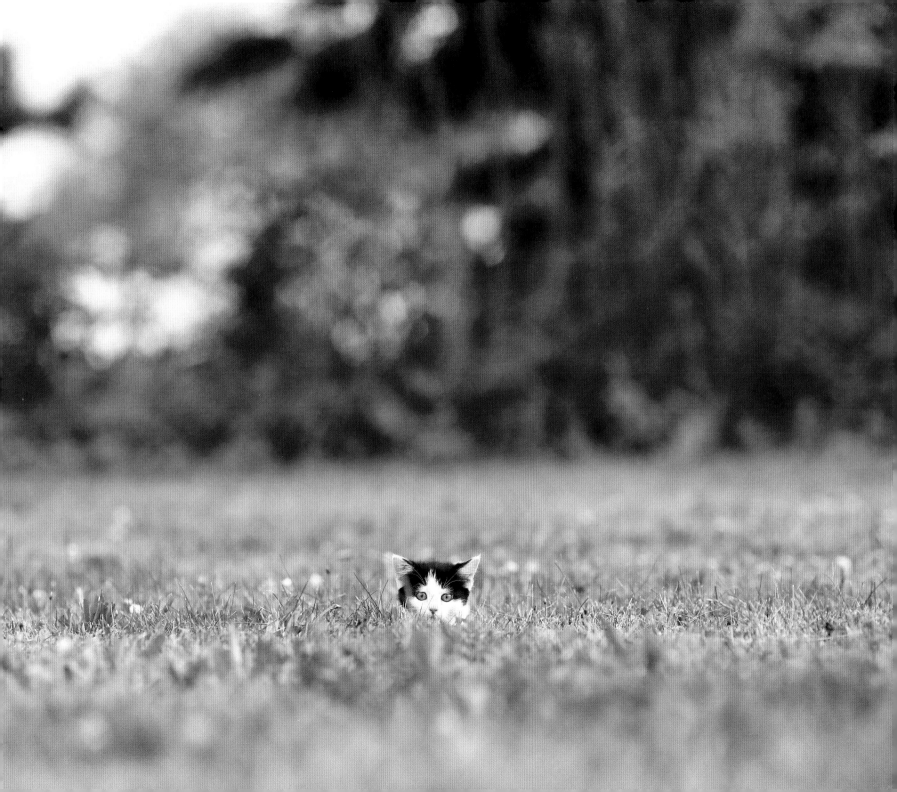

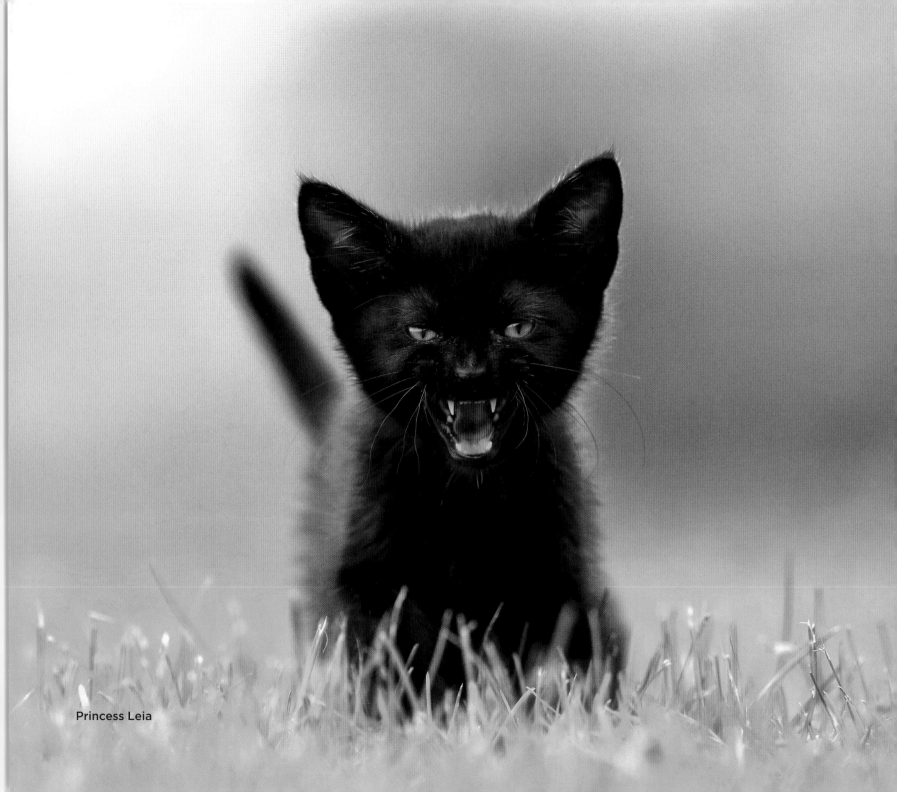

Princess Leia

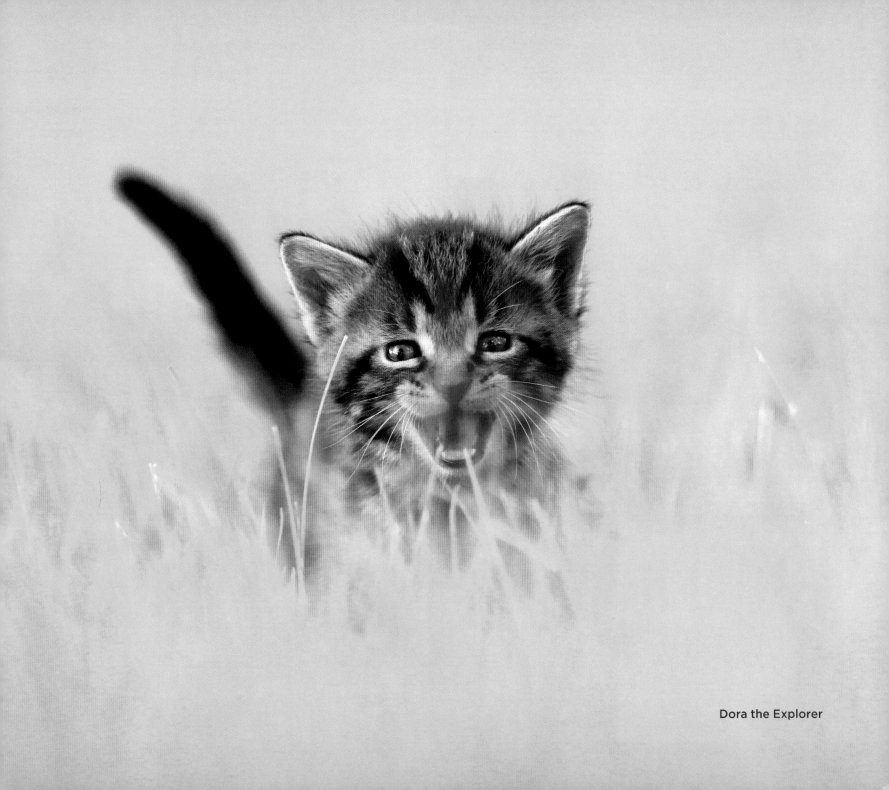

Dora the Explorer

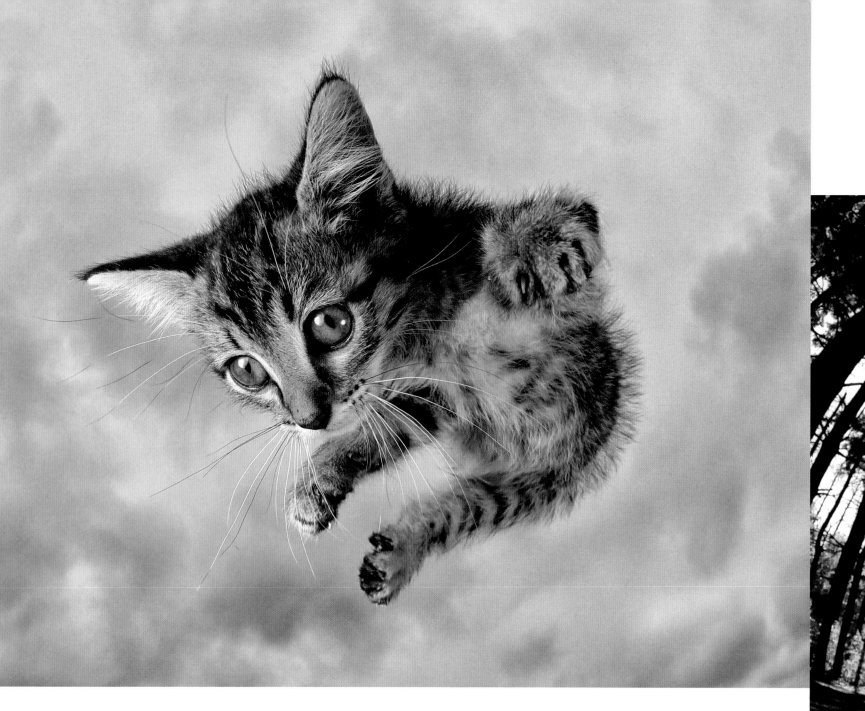

Toto

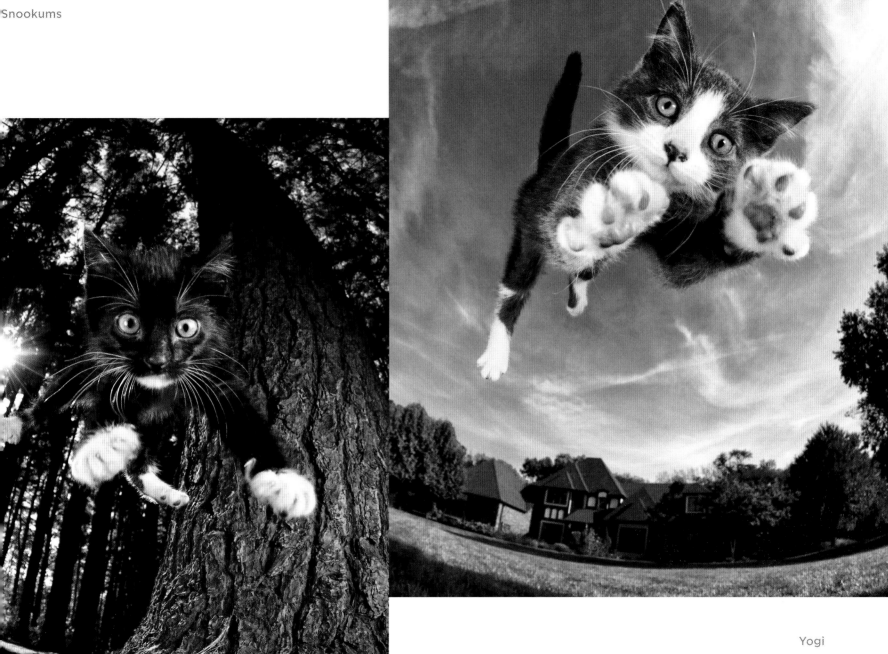

Snookums

Yogi

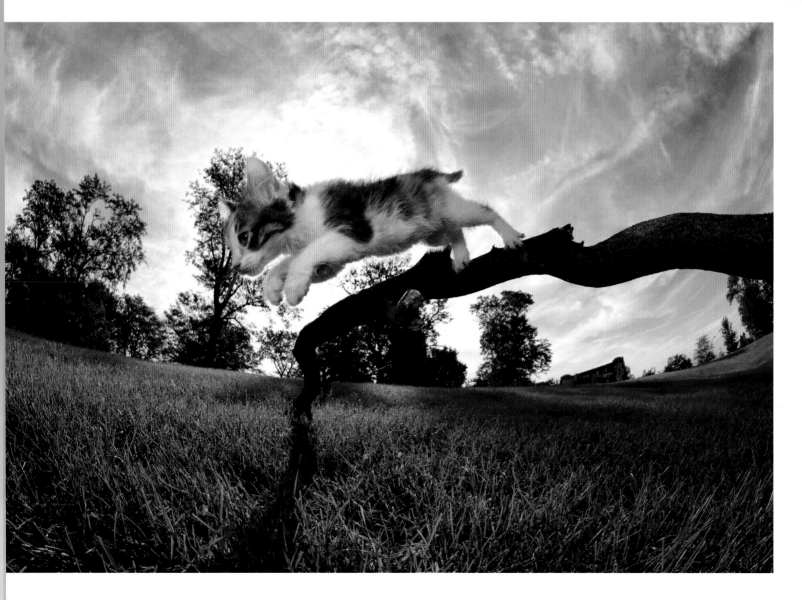

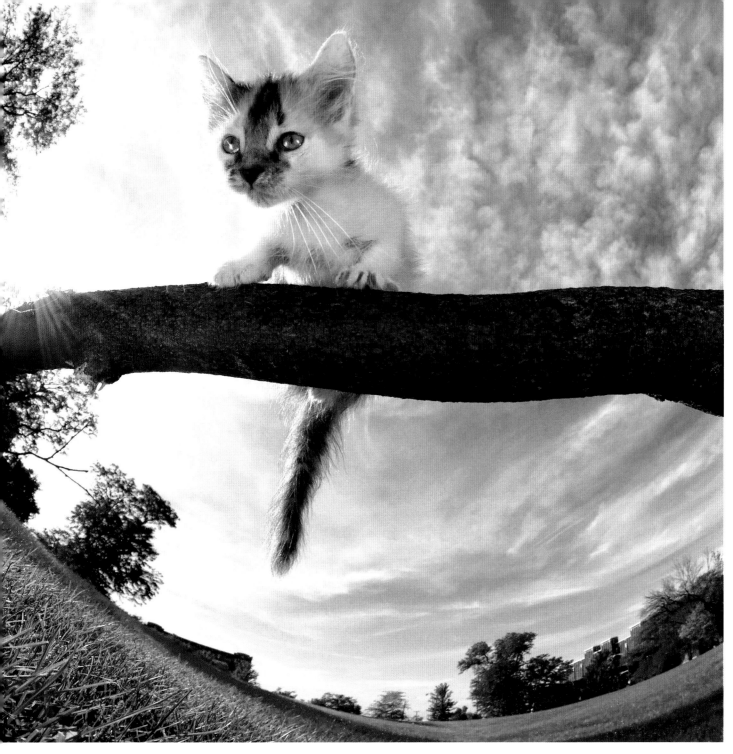

Yoda

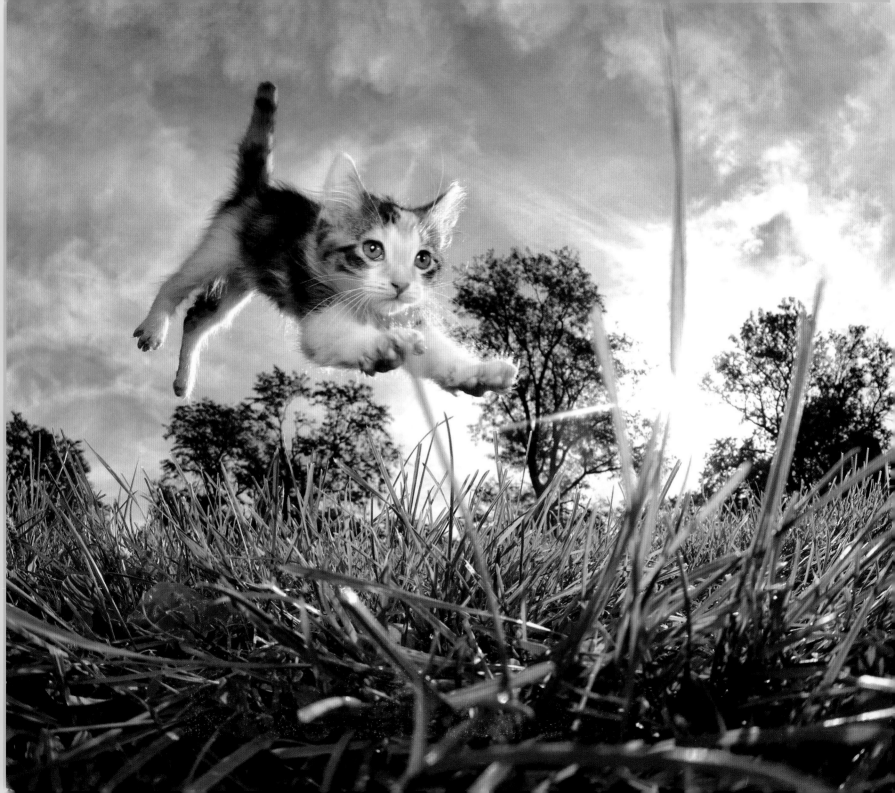

Cuddles

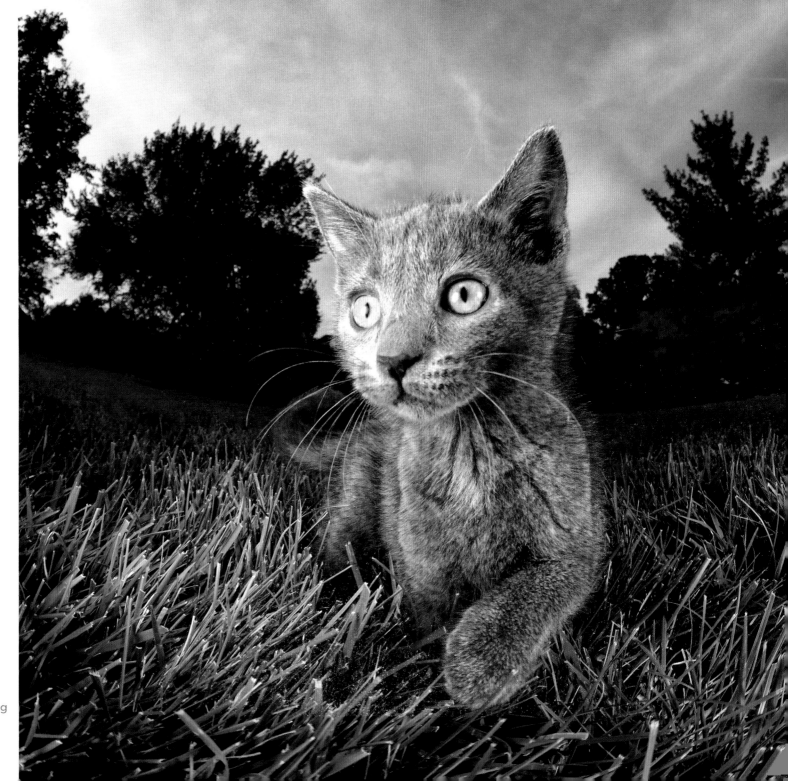

Doodle Bug

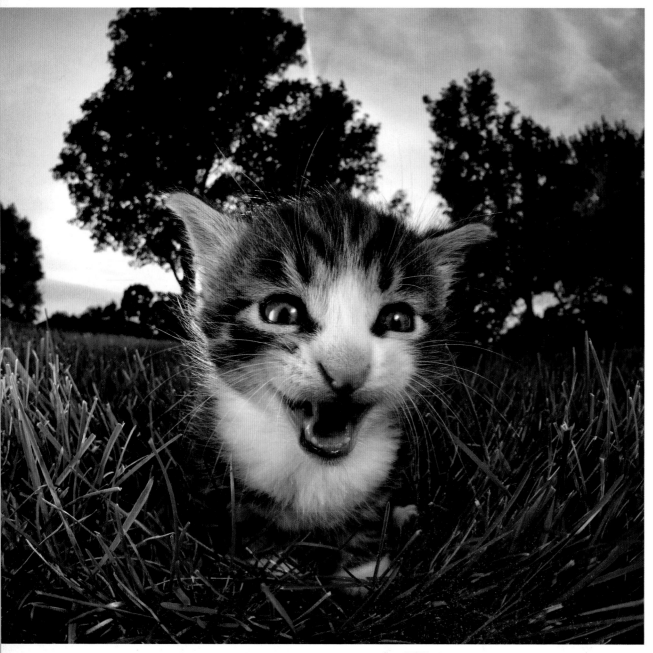

Chicken

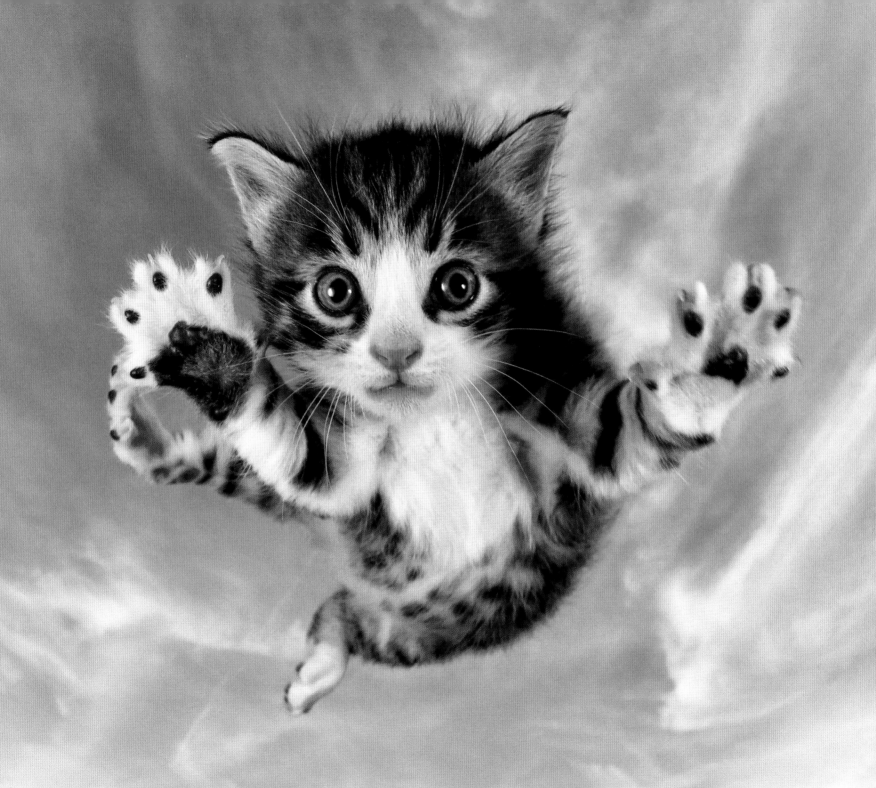

ABOUT SETH CASTEEL

Seth Casteel is an award-winning photographer and the author of the national bestsellers *Underwater Dogs* and *Underwater Puppies*. His photographs have been featured in various media, including the *New York Times, National Geographic Magazine, Morning Edition,* the *Washington Post,* the *Today* show, and *Business Insider,* as well as on the front page of outlets such as AOL, MSN, Yahoo, and hundreds of others. He lives in California.

ACKNOWLEDGMENTS

Thanks to each and every kitty that participated in the creation of this book, even if you pounced into my hair.

Thank you to my literary agent, Michelle Tessler; my editor, John Parsley; and Little, Brown and Company for believing in my photography and my mission.

Special thanks to TEAM POUNCE for all their support:

Jackson Galaxy

Hannah Shaw—Kitten Lady

Carli Davidson

Toonces the Driving Cat

Josh Feeney

Shirley Stanley

Gabriela Garcia

Eziel Gonzalez

Carol Reyes

Jessica Lessard

Lauren Vacek

Amy Wolf

Michelle Cintron

GreaterGood.org

Scott Stulberg and Holly Kehrt

Gary Tooth of Empire Design Studio

I would like to extend my sincere appreciation to the following animal-welfare organizations for providing rescue cats and kittens for play-time photo shoots:

CALIFORNIA
Found Animals, Best Friends Animal Society, Cat House on the Kings, Los Angeles Animal Services

CANADA
Cat Tails Rescue, Inc.

ILLINOIS
Macon County Animal Control and Care Center, Decatur and Macon County Animal Shelter Foundation, Chicago Animal Care and Control, Critical Animal Relief Foundation

MINNESOTA
Feline Rescue, Inc., Adopt-A-Pet Shop, Pet Project Rescue

PUERTO RICO
PR Animals, Save a Gato, Alley Cats and Dogs